DISCARD

W9-AVT-046

Riverside Park

The Splendid Sliver Riverside Park

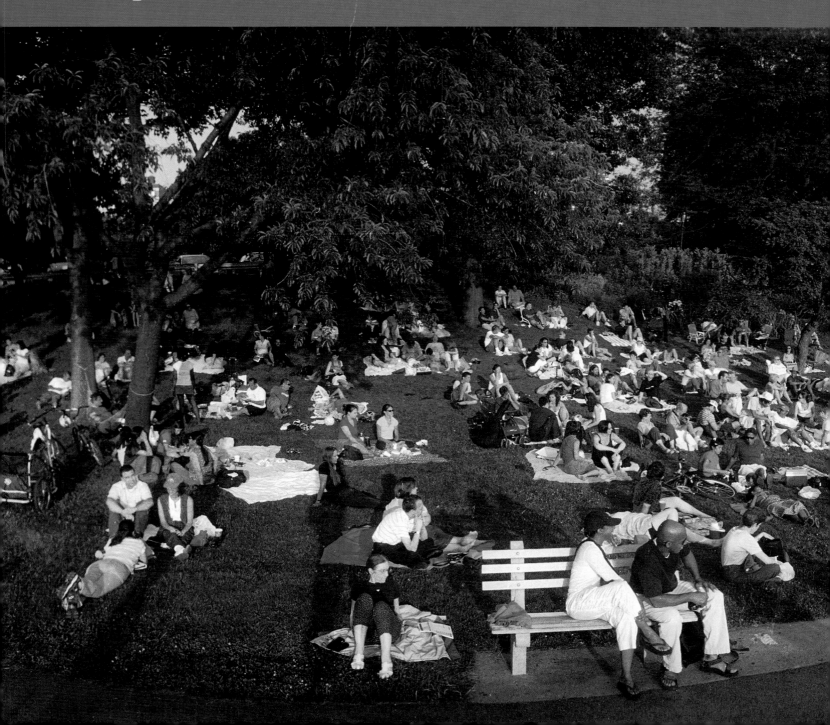

Edward Grimm

PHOTOGRAPHS BY
E. Peter Schroeder

974.71
GRI
SHELBYVILLE HIGH SCHOOL

Riverside Park

25076

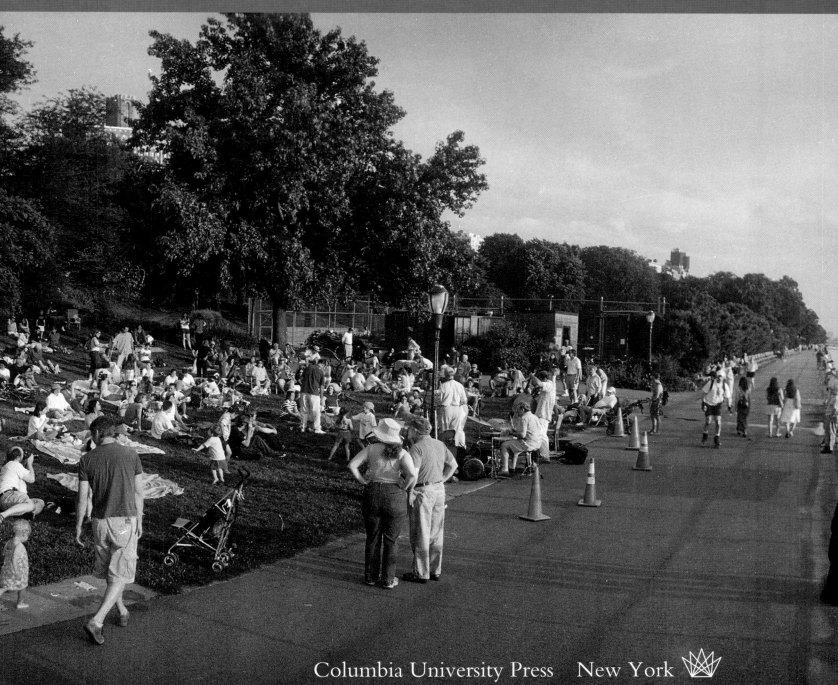

Columbia University Press New York

Columbia University Press
Publishers Since 1893
New York Chichester, West Sussex
Color photographs copyright ©2007 E. Peter Schroeder
Text copyright ©2007 Edward Grimm
All rights reserved

Columbia University Press gratefully acknowledges a grant from *Furthermore: a program of the J. M. Kaplan fund*, which has greatly aided the publication of this book.
Library of Congress Cataloging-in-Publication Data

Grimm, Edward.
 Riverside Park : the splendid sliver / Edward Grimm ; photographs by E. Peter Schroeder.
 p. cm.
 Includes index.
 ISBN 978-0-231-14228-1 (cloth : alk. paper)—ISBN 978-0-231-51219-0 (e-book)
 1. Riverside Park (New York, N.Y.)—History. 2. Riverside Park (New York, N.Y.)—Pictorial works. 3. Riverside Drive (New York, N.Y.)—History. 4. Riverside Drive (New York, N.Y.)—Pictorial works. 5. New York (N.Y.)—History. 6. New York (N.Y.)—Pictorial works. I. Schroeder, E. Peter, 1924– II. Title.

F128.65. R5G75 2007
974. 7´1—dc22 2007015536

Columbia University Press books are printed on permanent and durable acid-free paper.
This book is printed on paper with recycled content.
Printed in China

c 10 9 8 7 6 5 4 3 2 1

Preface

How do you measure a park? Is it merely a matter of length and varying widths, of contours and elevations? Or is it something more: the dimensions of pleasure it provides for those who walk its paths, sit beneath its trees, play on its fields?

We call Riverside Park "The Splendid Sliver" because of the elongated four-mile course it takes along the Hudson. But there is nothing narrow about the role it plays in the lives of the thousands upon thousands who visit it each year and avail themselves of all it has to offer. Whether it is a toddler pushing off on a playground swing or an elderly couple serenely watching bicyclers from a park bench . . . whether it is a birdwatcher spying a yellow-billed cuckoo or a soccer player streaking across the greenness of a playing field, there is something here for everybody.

Riverside Park's history is rich, and its future beckons promisingly. It is, without argument, a park for all seasons. Come with us across the years and along its paths as we tell its story in words and pictures.

EDWARD GRIMM

E. PETER SCHROEDER

Contents

In 1868, Frederick Law Olmsted proposes a park that will make the most of a steep and rugged landscape. . . . *The New York World* predicts it will be "beautiful in the highest sense," but garbage dumps and railroad tracks threaten to make a mockery of that prediction. . . . Robert Moses takes charge in 1934, and the transformation begins. . . . The park becomes a scenic landmark in 1980, and, four years later, a Master Plan opens the way to the future.

Olmsted designs a winding boulevard that will never lose sight of the river. . . . Riverside Avenue opens in 1880 and becomes a magnet for everyone from bicyclists to millionaires looking to live near "the American Rhine." . . . Mansions give way to apartment houses on what is now Riverside Drive. . . . A march of monuments and memorials, from Eleanor Roosevelt to Ralph Ellison.

From sledding in the winter to sunset concerts in the summer, a park whose calendar is crammed with things to do. . . . Thousands of volunteers working tens of thousands of hours each year make the park "greener, cleaner, safer and better." . . . A park of natural beauty, with 13,000 trees and 100 species of birds. . . . A waterfront that offers everything from kayak lessons to visits by *The Clearwater* environmental sloop.

The park is extended south of Seventy-second Street as part of the city's waterfront revival. . . . The goal: to connect with Hudson River Park to the south. . . . Bike paths, recreation fields and picnic lawns spring up. . . . A 750-foot-long pier reaches out into the Hudson for those who run, fish, or simply want to see the George Washington Bridge in the distance.

Foreword

A Distinctive Green Space

In a city of nonstop and often feverish activity, Riverside Park's diverse beauty provides abundant opportunities for relaxation and recreation. Its history is the stuff of drama, and its future is filled with promise.

Most parks boast of trees, and many host playgrounds and sports facilities. Some embrace water. Riverside Park encompasses all these features and more. Its most defining aspect, however, may lie in another realm: a heart as big as all outdoors. The park inspires extraordinary devotion. Community commitment has propelled its renaissance. Neighborhood activities spark its liveliness. Citizen volunteers work to enhance its beauty. Families provide financial support for its upkeep and improvement.

The pleasures of Riverside Park are both active and passive; its users are young and old; its beauty is natural and cultivated; and its spirit is both lively and contemplative. For those of us who know and cherish the park, this book reflects our pride. For those who have yet to discover Riverside Park, consider it an invitation to explore.

JAMES T. DOWELL
PRESIDENT
RIVERSIDE PARK FUND

Riverside Park

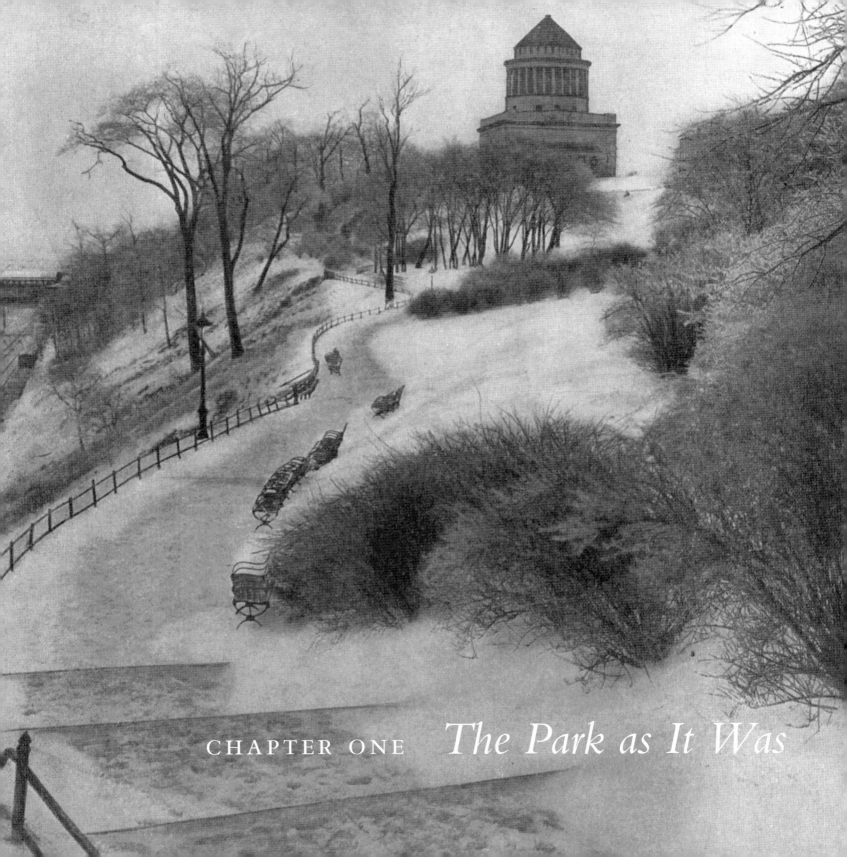

CHAPTER ONE *The Park as It Was*

I N 1789, when New York was the nation's
capital, President George Washington would
seek relaxation by traveling by horse and carriage
from Fraunces Tavern, north and west to the
river, then along Bloomingdale Road (today's Broadway).
Along the way, he would pause for visits with friends whose
houses and gardens overlooked the Hudson River.

There was no denying the scenic beauty of either the river
or the rugged and curving landscape that bordered it. One
morning in the 1830s, author James Fenimore Cooper,
standing on Claremont Hill, just north of the current site of
Grant's Tomb at 122nd Street, was awestruck by what he saw
and felt:

I scarce remember a lovelier morning: everything appearing to

The bustling freight yards of the
New York Central and Hudson River Railroad
are depicted in this nineteenth-century
woodcut. Huge quantities of grain arrived
regularly at the elevator at Sixty-first Street and
the North River beginning in 1879.

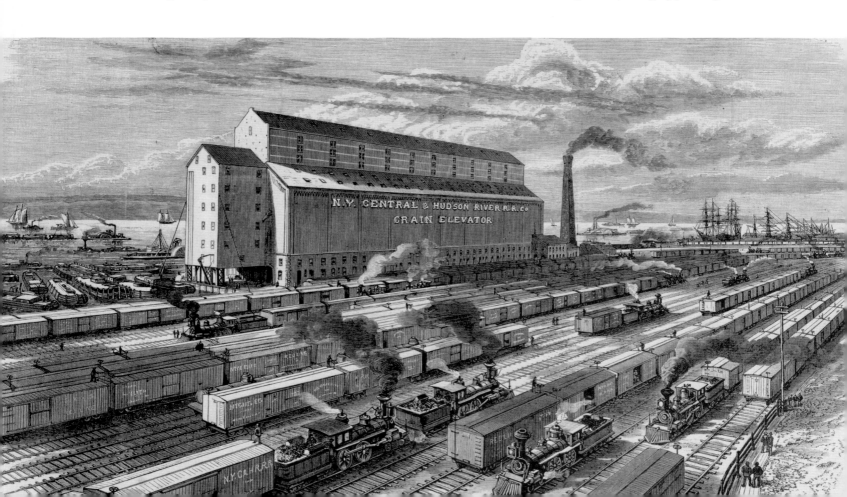

harmonize with the glorious but tranquil grandeur of the view, and the rich promises of a bountiful nature. . . . The birds had mated and were building in nearly every tree; the wild flowers started up beneath the hoofs of our horses, and every object far and near seemed to my young eyes attuned to harmony and love.

Such an idyllic scene would prove to be short-lived. In 1846, the Hudson River Railroad laid tracks along the river to speed the transport of freight from Albany to Manhattan. That freight included dairy and produce goods from farms to the north, as well as meat and poultry, all of it destined for the Stock Yards Company Building on Forty-first Street.

By the 1860s, the city was growing fast and, while the east side of Manhattan was developing at a lively pace, the west side was more notable for its unpaved streets and empty lots. But the need to expand industrial and mercantile growth became a powerful force for change on both sides of town. So did the need to house the city's growing immigrant population.

The idea of expanding the grid of streets not only north but west to the Hudson River shoreline gained many adherents. Central Park Commissioner William R. Martin, however, was seeing things differently. Arguing that the city's tax base would benefit, in 1865 he proposed a scenic carriage drive and park along the river. The park was to contain eighty-nine acres and cost $7,250,000, or more than $80,000 per acre. Albany agreed to the ambitious plan, and the first segment of the park was acquired in 1872. Now the search began for an architect to take on the formidable task.

IN 1807, the City Council got state approval to establish a comprehensive street plan for Manhattan. Three influential New Yorkers—John Rutherford, Gouverneur Morris and Simeon De Witt—were given power to establish a permanent system.

The grid idea was already popular in other cities—even the baroque diagonals of Washington were overlaid on a right-angled crisscross of streets. In 1811 the New York commissioners published their eight-foot-long map, showing 12 main north-south avenues and a dense network of east-west streets for much of Manhattan, with the old angled road of Broadway meandering through. Their stated goals were "a free and abundant circulation of air" to combat disease, and an overpowering rectangularity, since "straight-sided and right-angled houses are the most cheap to build."

Christopher Gray, *New York Times*,
October 23, 2005

Enter Olmsted

The selection process didn't take very long. In 1873 the job went to Frederick Law Olmsted, the Connecticut-born

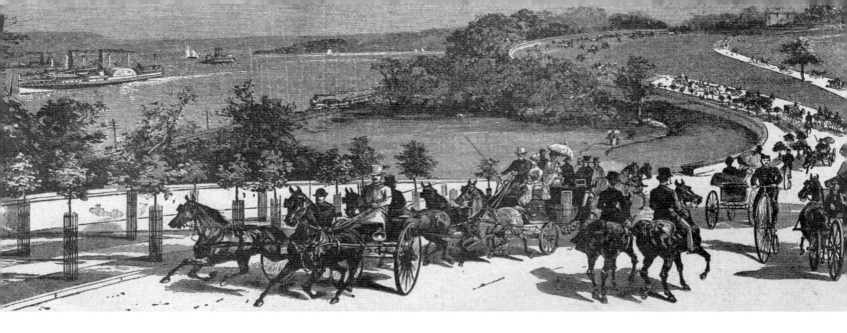

Carriages and bicycles vied for space in this Riverside Avenue scene from the 1880s. Below them are the newly formed contours of Riverside Park, river traffic, and one of the freight trains that brought produce to the city—and problems to the park.

landscape architect who, together with architect Calvert Vaux, had designed Manhattan's Central Park. City officials approved an Olmsted plan that included not only Riverside Park and Drive but Fort Washington Park and Morningside Park.

Olmsted believed that large parks offered an invaluable respite from a city that even then could frazzle and tire its residents. He summed up what could be called his credo this way: "Beautiful, natural landscape is enjoyed, consciously or unconsciously, by all, old and young, by those who drive or ride, and by those who walk or go in boats. Large parks containing natural landscape can be enjoyed by greater numbers of people, with less trouble and expense to themselves, than any means of amusement supplied at public expense."

Olmsted now turned his attention to the rambunctious site assigned to him. He foresaw "a prospect of rare extent, real beauty and much variety of interest." Riverside Park, he wrote in a March 29, 1873, report, "would not merely be an addition to the existing pleasure grounds of the city but

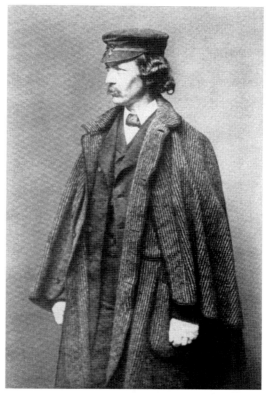

would supply a want which neither the Central Park nor any other has been designed or can be adapted to meet." He even envisioned World's Fairs held on its grounds.

Riverside Park's Landmark Designation Analysis of 1979 describes the Olmsted Plan this way: "He combined the land purchased for the avenue and that purchased for the park. He considered the existing grades and contours, the existing plantings and views, and designed a winding drive that would be comfortable for horses and pleasure driving, provide shaded walks for pedestrians, and yet would give easy access to real estate bordering it on the east."

"His inspiration was to make the most of the natural beauty by combining the land available for the avenue with the land for the park. He proposed designing a drive that

(above) With the design of New York's Central Park already part of his portfolio, Frederick Law Olmsted was given the job in 1873 of carving a park out of the challenging terrain flanking the Hudson River. In his eyes, it presented "a prospect of rare extent."

(left) A Parks Department photo in its 1908 annual report shows the view south from 111th Street. Apartment houses had already begun to line Riverside Drive, but the park would wait another quarter-century for any major development.

(right) The southern gateway to the park at Seventy-second Street has proved to be a natural site for pieces of art. This bronze electric light standard was given to the city by the Colonial Dames of America in the early nineteenth century. Today, a monument to Eleanor Roosevelt occupies the site.

(below) A new century arrives, and, whether for strolling or reading a newspaper, Riverside Avenue (renamed Riverside Drive in 1908) provides a source of leisure-time enjoyment for the growing West Side population.

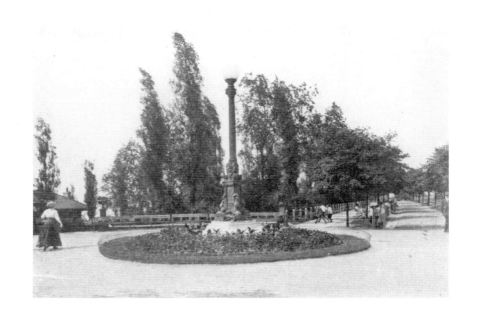

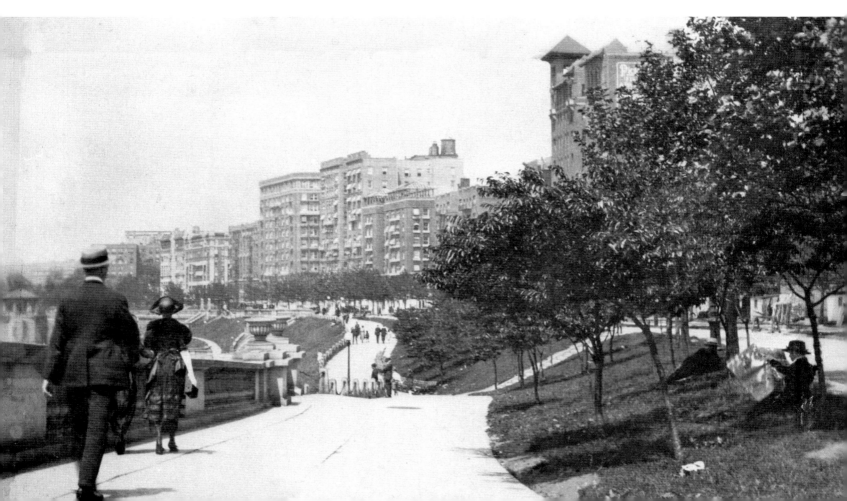

would curve around the rock outcroppings and valleys," says Charles McKinney, Riverside Park administrator from 1984 to 2001.

From that boulevard, the park would slope down to the railroad tracks that followed the banks of the river for half the length of Manhattan. In Olmsted's plan, the inside of the park was to be left unplanted so as to preserve the views of the river. In actuality, however, it was laid out by Parks Department engineers with paths and plantings in the English gardening style.

In 1878, Olmsted was released by the Parks Department. After two decades of service to the city, writes Albert Fein in *Landscape Into Cityscape*, he had paid a price for his "stubborn integrity" and his belief that ability should take precedence over politics in matters of landscape architecture. His duties were taken over by Calvert Vaux, who pledged to complete Riverside Park "as best he could." For the next thirty-five years, he and other architects and horticulturists brought the park into being between 72nd Street and 125th Street.

As for Olmsted, he moved back to New England, where he lived in Brookline, in the Boston suburbs, until his death in 1903.

Paradise Lost?

As early as April 24, 1892, the *New York World* commented that Riverside Park "will be . . . dedicated forever to the use of people, beautiful in the highest sense." But there was nothing beautiful about the coal bins and garbage dumps along the four-track railroad bed that separated park and river. There were squatters' shacks and sewerage problems. Coal dust from passing trains smudged the air wafted up to residences along the future Riverside Drive.

IN 1850, when the Hudson River Railroad planned a freight connection between Manhattan and Albany, tracks were laid directly next to the Hudson. Along this route, produce and dairy items were delivered from farms in the north, and poultry and other meat products were brought directly to the Stock Yards Company Building on 41st Street. . . . The trains ran right next to the streets until 1934, when the West Side Improvement Project was initiated to clear the streets for vehicular traffic. . . . When the project was finished, the tracks led from the Bronx to a terminal on Spring Street, with rail yards at 30th and 60th Streets, where trains could be stored and the freight was redistributed. . . . The casualties of these developments were 640 demolished buildings and the West Side Cowboys. Previously, every train moving downtown along the Hudson had been preceded by a man on horseback, waving a red flag to warn traffic of the approaching train, which inched along behind him at a speed of six miles an hour.

Julia Solis, *New York Underground: The Anatomy of a City*

There was one notable improvement. In 1901, a new viaduct bridged the Manhattan Valley from 129th to 135th Street. This "fantasy of masonry and metalwork," as Eric K. Washington describes it in *Manhattanville: Old Heart of West Harlem*, allowed the scenic boulevard to extend northward from its original 129th Street boundary to beyond 150th Street. The viaduct had an amazing 130-foot-wide semicircular arch that spanned Manhattan Street as well as several balconies on its upper sidewalks. It was hailed in *Scientific American* as an outstanding feat of engineering.

Nonetheless, by 1921, the park, which now ran north to

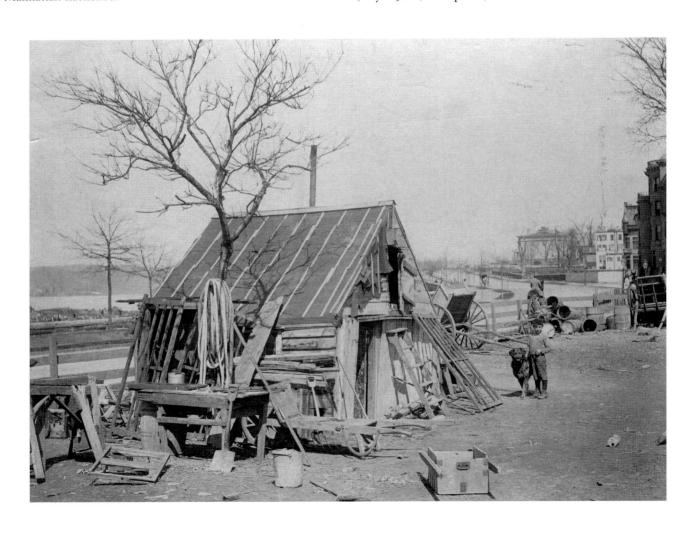

They weren't pretty, but they were a fact of life in the 1880s. Squatters' shacks like these on the northeast corner of Eighty-second Street and Riverside Avenue proliferated as the momentum of the rich relocating from the East Side of Manhattan slackened.

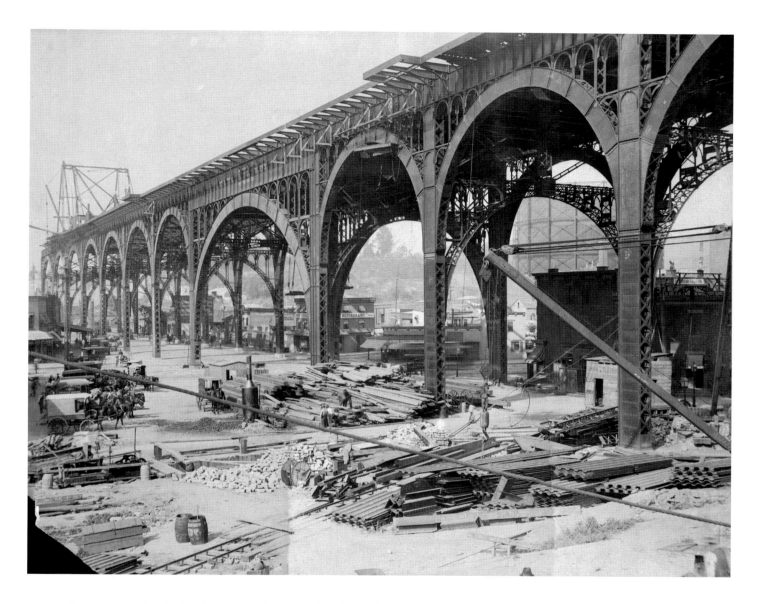

155th Street, had basically become "a wasteland, nothing but a vast low-lying mass of dirt and mud," Robert Caro writes in *The Power Broker: Robert Moses and the Fall of New York*. In addition, he writes, there was "the stench along Riverside Drive from trains carrying carloads of cattle and pigs to the downtown slaughter houses."

Spanning the Manhattan Valley from 129th to 135th Street at 12th Avenue, a viaduct completed in 1901 and hailed as an engineering feat made possible the northern extension of Riverside Avenue. It took four flat rail cars to move its 130-foot girders.

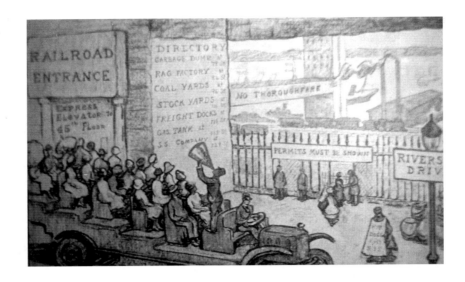

Community activism has long been a staple of Manhattan's Upper West Side history. This 1929 cartoon depicts an outcry against overdevelopment of Riverside Park and Drive. A half-century later, proponents of Westway would face the same kind of resistance.

When Moses became commissioner of a unified five-borough Parks Department in 1934, he set about eliminating that "wasteland" by scrapping the improvement plan then on the books and embarking on his own course of action with his trademark energy and decisiveness. There was no questioning his zeal for the undertaking. "If the West Side does not stir you," he once remarked, "you are a clod, past redemption."

Changes came thick and fast. The park's size was almost doubled by the more than 130 acres of new parkland created along the Hudson's shores by designers Gilmore D. Clarke and Clinton Lloyd. The landscape was terraced down three levels to a manmade promenade and shoreline. Massive retaining walls, trimmed with granite and marble, were built. The Henry Hudson Parkway was created, and the railroad tracks from 72nd Street to 125th Street enclosed in a tunnel.

More than twenty tennis and basketball courts, baseball fields, and playgrounds sprang into being. A new marina at Seventy-ninth Street became the port of call for yachts, sailboats, and visiting ships from many parts of the world.

Newly named parks commissioner Robert Moses brought about momentous changes in the 1930s, almost doubling the size of the park in a three-year period and creating new facilities that included playing fields and a marina at Seventy-ninth Street.

IN AN INTERVIEW published in *New York: An Illustrated History*, Robert Caro, author of the definitive biography of Robert Moses, described Moses' infatuation with Riverside Park. Although he lived on Central Park West, Moses would insist on being driven over to Riverside Drive on his way home from his job.

He would gaze down at the park and its shoreline, and what he saw saddened him, said Caro, because of the "miles of muddy wasteland," the "rusted barbed-wire fences that cut the city off completely from the waterfront," and the soot from railroad engines that would float up to the apartment windows of residents on Riverside Drive. "If they had to open the windows in the summer, they were kept awake all night by the clang and the coupling of the cars." There were shantytowns, too, Caro continued, and "as night fell, you could see the cooking fires of the hobos . . . starting to flicker in the darkness."

One day, as Caro tells the story, Moses said to Frances Perkins, President Roosevelt's secretary of labor, "Frances, couldn't this waterfront be the most beautiful waterfront in the world?"

"He started to talk to her," said Caro, "about this great highway that could run up along the water and this beautiful park that could be beside the highway and how the highway and the park would cover the railroad tracks. And the thing that most astonished Frances Perkins was that, in her words, 'he had it all figured out.'"

"Robert Moses was then twenty-four or twenty-five years old," said Caro, "a lower-level employee for a municipal reform bureau. He was talking about an urban public work on a scale unprecedented in America. And he had it all figured out."

(opposite page) A seaplane shares water space with docked pleasure craft at the Seventy-ninth Street Boat Basin in 1947. Seaplanes first took off in 1911 and by the end of the 1930s had become pioneers in transcontinental flight.

(below) In 1939, children enjoy one of the many playgrounds created by Robert Moses in his Riverside Park revitalization project. Given the ever-growing number of West Side families, increasing the number of such recreation areas was essential.

Also at Seventy-ninth Street, a rotunda was created, with a fountain and terraces overlooking the river. Designers and engineers came from far and wide to admire and study it.

There were new paths, stairways, and plantings. "The English gardening ideal had given way to a park in which human needs and activities, not nature, determined the plan," writes Charles McKinney. It was all done in three years at a cost of $150 million. All levels of the park were now in use, as visualized by Olmsted's original plan. Lewis Mumford, architectural critic and urban planner, pronounced the entire project "the finest piece of large-scale planning since the original development of Central Park." The praise was not unanimous, however. In his biography of Moses, Robert Caro

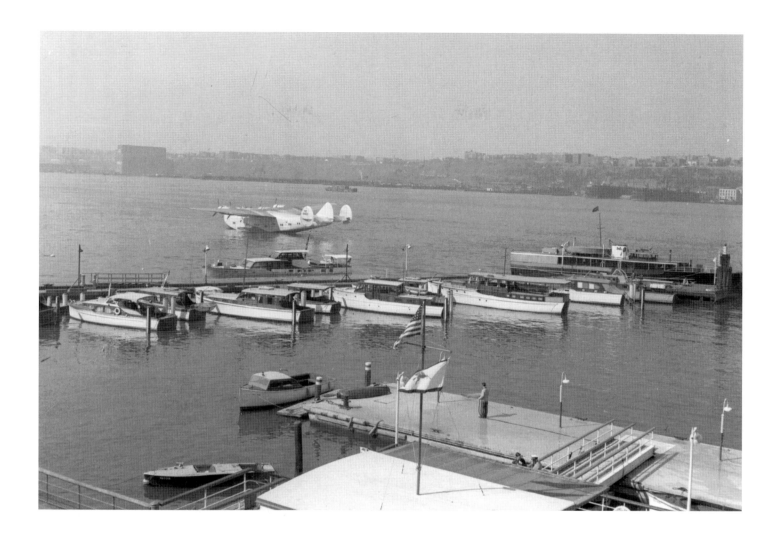

A MUNICIPAL small boat basin in the Hudson River off Seventy-ninth Street will be opened to public use without ceremony by the Park Department today. . . . The basin is built in the form of a hollow square, with runways forming three sides and the brick seawall along the shore making the fourth side. It is built just below the traffic circle on the Henry Hudson Parkway. Inside the circle is a garage for parking the automobiles of yachtsmen using the basin.

The basin will be operated by a concessionaire on contract with the city. A sliding scale of rates for mooring, fresh water and service by the day, month and season has been agreed upon by the operator and Park Department. The monthly rate for boats is about $25.

New York Times, April 1, 1938

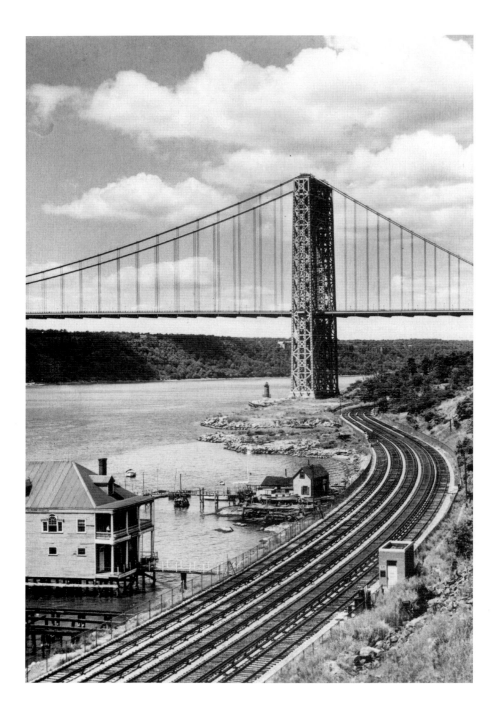

This 1932 photograph by Samuel Gottscho shows a northward view of the railroad tracks and George Washington Bridge. Robert Moses was to be criticized for his failure to cover the tracks north of 125th Street and, his critics contended, neglecting the northern part of the park in terms of new development.

writes that the plan was criticized for shortchanging Harlem residents by creating only one playground in the northern section of the park. Moses also left the railroad tracks uncovered north of 125th Street. In addition, says Caro, the improvements to the park came at the cost of a highway that denied access to—or even views of—the river.

More Problems Than Progress

Beginning in 1940 and continuing for decades, Riverside Park was the scene of little progress and much decline, caused by vandalism, neglect, and disrepair. The remedies needed were many and drastic. There were recreational facilities to be repaired, landscapes to be restored and maintained, trees to be protected from Dutch Elm disease, and security to be stepped up.

In 1980, the year that the park was designated a New York City scenic landmark from 72nd Street to 129th Street at St. Claire Place—it is also on the National Register of Historic Places—a community-led restoration effort began. One major goal was blocking an interstate highway that was to run from the Battery Tunnel to Forty-second Street and, from there, north to the George Washington Bridge. Known as Westway, it would have tunneled through 200 acres of landfill in the Hudson.

Westway's boosters would have profited from doing their homework. As early as 1870, civic groups had organized to protect parts of the shoreline from commercial use and to ban refuse dumping and loading from piers along the shore. Now, an outcry against the plan, which would have encroached irreparably upon the park, resulted in its abandonment in 1985. The clinching argument against it? Its potential damaging impact on the striped bass population. Westway had been beaten back and, instead, $1.3 billion of highway funds were used to improve the city's public transit system.

Turning the Corner

In 1984 the *Riverside Park Conceptual Master Plan* was completed by the Parks Department. It called for everything from graffiti removal to erosion control and an ambitious long-term investment of city funds. A capital plan was prepared for setting priorities among the many projects, including slope restoration, strengthening the park's retaining wall, improvements to the pedestrian mall, and horticultural planning.

Two years later, the Riverside Park Fund was organized to work with New York City's Parks Department on restoring and maintaining the park. The Fund has been busy ever since, rebuilding playing fields and playgrounds, improving existing planted areas and developing new ones, and conducting school and family programs and cultural and recreational events.

On Earth Day 2006, the Fund received one of the twenty awards conferred by the U.S. Environmental Protection Agency for outstanding efforts to improve the environment in EPA Region 2, which includes New York State. The Fund received a 2006 Environmental Quality Award for its volunteer program, horticultural projects, creative playgrounds, and other initiatives that, said the EPA, have made Riverside Park "a cleaner, greener and safer recreational space."

Throughout its existence, Riverside Park has continued to evolve and adapt itself to change. Its history has been tumultuous but never uninteresting. Now, with its expansion southward well underway, it is poised for future growth and development. Like the great river on its flank, it seems destined to keep moving with the times.

CHAPTER 2 *Along the Way*

I N 1980, both Riverside Park and Riverside Drive were designated scenic landmarks by New York City's Landmarks Preservation Commission. It seemed only fitting since the history and fortune of the two had long been linked. Each is the site of monuments, both grand and simple, and each provides tranquil pleasures in a city that hums with almost nonstop activity. As Paul Goldberger of the *New York Times* observed in a 1980 article, the proximity of the Hudson River, "ever present, ever visible, brings a certain kind of reassurance that few other parts of the city can equal. . . . From any point in the park, the great river flows on one side, the great wall of buildings holds fast on another."

Riverside Drive runs parallel to the park from 72nd Street

(top, opposite page) The wedding of Mary Clark and Washburn Hopkins is celebrated on June 3, 1893 at the Cyrus Clark mansion at 175 Riverside Drive.

(bottom, opposite page) A serene 1916 view of the park north of Grant's Tomb. But soon after the new century arrived, automobiles made their first appearance on Riverside Drive. It had become clear that the bicycle no longer ruled the road.

All may have been serene along some sections of the drive, but this was the scene at 115th Street as the first stages of the park's massive face-lift produced this temporary wasteland of rubble.

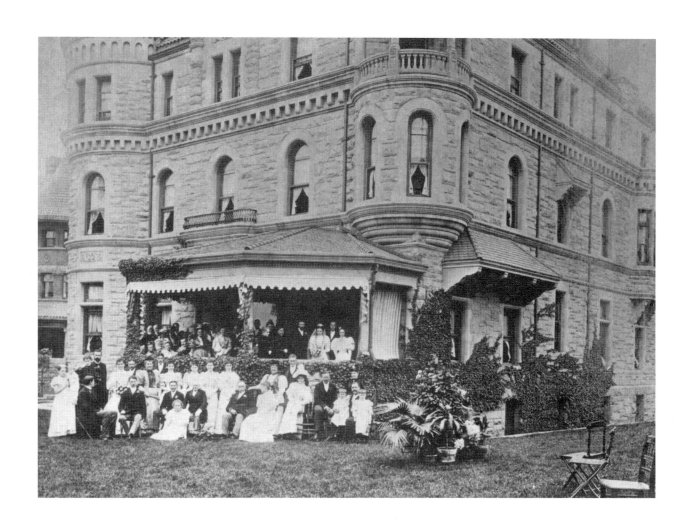

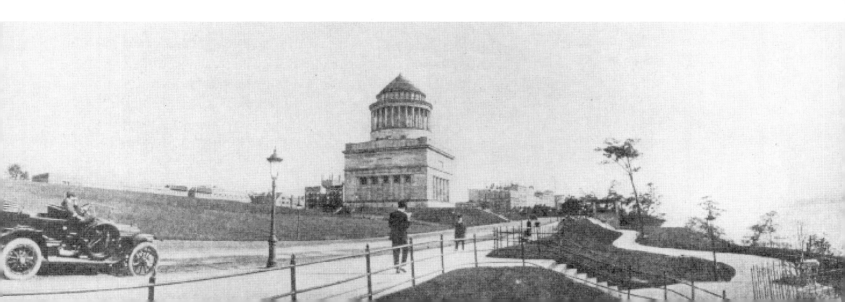

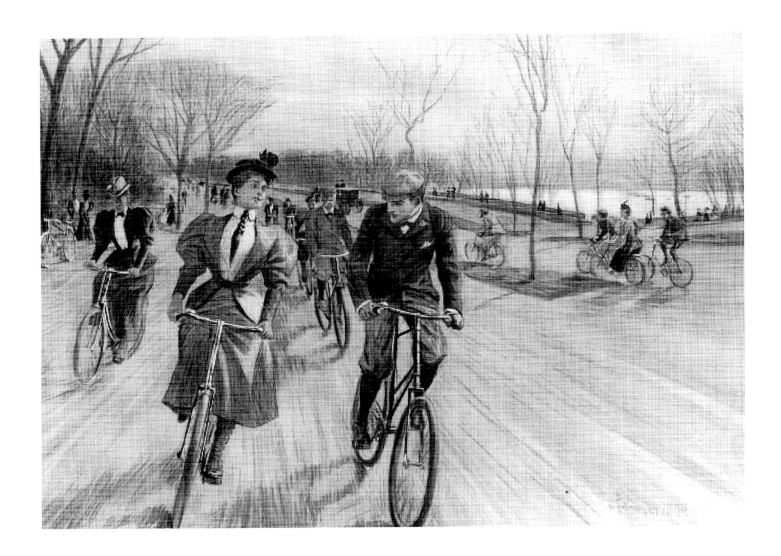

An Afternoon Spin on Riverside Drive, by William Thomas Smedley, shows, in his words, "the ever merry bicyclers" on an outing. Smedley was a popular magazine illustrator of the late nineteenth century and a member of the Society of American Artists.

to 125th Street. A viaduct carries it over the Manhattanville valley and up to 135th Street. From there, it wends its way northward to Dyckman Street in Inwood, although its main residential section ends at 165th Street. It is a gracefully curving thoroughfare that Frederick Law Olmsted wanted to be the most beautiful boulevard in the world. It may well be.

THE DRIVE got its start . . . as Central Park was nearing completion. . . . A design was provided by one of the earliest of the Drive's prominent residents, Egbert Viele, a civil engineer and now-forgotten rival of Olmsted. . . . After major design revisions by Olmsted, the work got underway . . . , with frequent interruptions for criticisms and argument. . . . When the job was nearly completed in late 1879, a final dispute over money led the builder to close off the few existing cross-streets with stones, derricks, and timbers, with guards posted to arrest trespassers. While the wrangling continued in court, Viele, for one, complained of having to brave the squalid yards and vicious dogs of neighborhood squatters in order to reach home. Finally, late on the night of May 7, 1880, a hundred or so "unnamed individuals" marched into the Drive and hurled the hated obstructions over the wall into the park. The next morning the carriages of the elite rolled blithely along in the spring sunshine, and the brand-new showplace was open at last.

Peter Salwen, "Visible City," *Metropolis*, May 1983

First Came Riverside Avenue

Olmsted's plan establishing Riverside Drive and Riverside Park, along with Fort Washington and Morningside Parks, received approval. A straight drive had been proposed, but, rather than hew to the city's grid pattern of streets, Olmsted decided to follow the natural topography. His plan called for a winding boulevard that would follow the terrain's natural lines from 72nd Street to 125th Street.

Olmsted envisioned an avenue laid out in varying widths and divided into sidewalks, paths, and carriageways—all of it retaining views of the waterfront and the cliffs of the New Jersey Palisades. Work began on Riverside Avenue in 1877, and the grand thoroughfare opened to the public in 1880. Five years later, it was extended up to 129th Street.

The 1880s were marked by a mansion boom on the avenue as wealthy merchants, eager to escape a crowded midtown, looked west to the new avenue and to a river that some called "The American Rhine." The first large, free-standing townhouse was the Cyrus Clark House at 175

IN 1904, after twenty years in Europe, Henry James returned to the United States and made a trip to his birthplace, New York City, which had almost doubled in population in his absence. In *The Hudson*, Tom Lewis describes what he discovered:

Uptown, James found, the topography of New York City had also changed. . . . James saw Riverside Drive and Columbia University, which had recently relocated from Madison Avenue and Forty-ninth Street to its new campus on upper Broadway. . . . He saw the hundred-foot-tall memorial to the Soldiers and Sailors of the Civil War that graced a broad esplanade in the recently completed Riverside Park at Eighty-ninth Street. And "on a bleak winter morning," he beheld at 122nd Street the imposing tomb of Ulysses Grant and his wife Julia. New York City, the "sordid city," James concluded, sat at the "Beautiful Gate" and commanded "the great perspective of the river."

The following year, James took a boat trip downriver and, writes Lewis was angered by the presence of the railroad on the landscape and how "the rows of steel snaking along the Hudson's shore had all but banished the idea of the contemplative journey."

Riverside Drive. Clark, a banker and popular civic leader, is remembered by a plaque in Riverside Park as "The Father of the West Side." Another formidable early residence was the Charles M. Schwab Mansion, a lavish seventy-five-room villa built in the style of a French Renaissance chateau and running the entire length of the avenue between Seventy-third Street and Seventy-fourth Street and east to West End Avenue.

The *New York Times* observed in 1895, "There is no boulevard in all the world that compares with Riverside Drive in natural beauty." In *Water Under the Bridge*, Margarette De Andrade notes, "All over the island huge edifices drive themselves into the heavens, but when they reach the Drive, the river compels them to stop. . . . Just as when light passes through a prism it reveals the true colors of the spectrum, Riverside Drive imparts the past, present and future of the island."

Encomiums like these notwithstanding, by the end of the century it had become clear that Riverside Avenue would be an address for only the moderately rich. The elite, with homes in Bar Harbor and Newport, concluded that they could live without the river views—and, most assuredly, the icy winds of winter. There were transit limitations, too, and a shortage of available servants, shopkeepers, and other conveniences.

And there were even more tangible problems. "There was smoke and noise from trains on the open New York Central tracks, which had occupied the right-of-way along the shore since the 1840s," writes Peter Salwen in *Metropolis*. "Sparks from passing locomotives occasionally reduced an acre or two of park to charcoal. And summer brought the fragrance of cattle trains, which paused beside the park—for days, sometimes—on their way to the Hell's Kitchen abbatoirs." The drive itself, according to Salwen, was marred by freight wharves, stables, coal dumps and squatters' shacks.

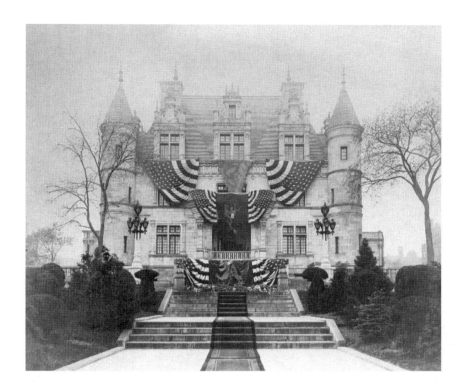

Built by steel tycoon Charles Schwab, the flag-bedecked Schwab Mansion was considered the most lavish home ever built in Manhattan. After Mayor LaGuardia declined to make it his official residence, it was razed and replaced by the Schwab House, an apartment complex extending from Seventy-third Street to Seventy-fourth along Riverside Drive.

With views like this, it's little wonder that the ranks of apartment houses grew after the mansion boom slackened. The first residential building was the nine-story Turrets at 125 Riverside Avenue. The 1930 view here is north from Ninety-sixth Street.

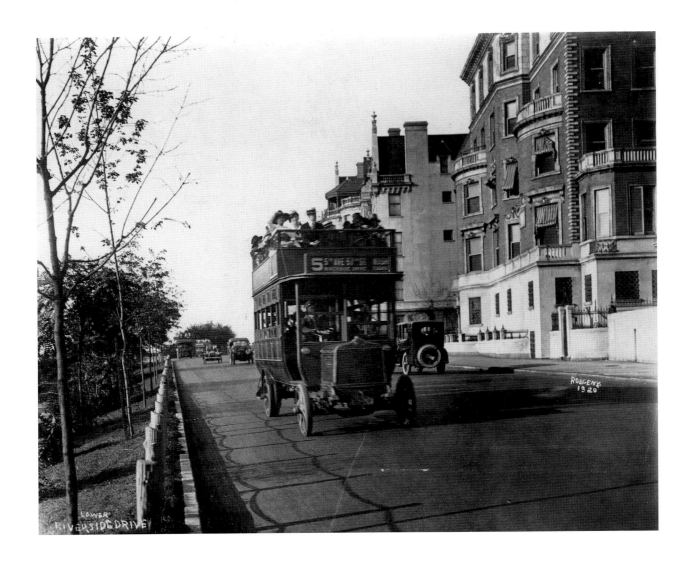

Passengers enjoy the open upper deck of one of the first Riverside Drive buses as it heads south toward its Fifth Avenue and Fifty-seventh Street destination. Today's M5 bus cruises the Drive from 135th Street to 72nd Street.

Architectural critic Lewis Mumford put it in personal terms: "I can understand the dejection that grew to desperation when a prosperous family discovered that the grand sweep of the river did not offset the putrid odors and hard west winds."

Despite those odors and winds, as the new century arrived, row houses began to sprout along the side streets

and, spurred by the 1904 opening of the subway, the ranks of apartment houses along the drive grew rapidly.

When it came to inducements, there were no limits. To begin with, as Andrew S. Dolkart reports in *Morningside Heights*, the buildings were given names that smacked of grandeur and elegance: The Devonshire, The Clarendon, The Yorkshire, La Touraine, Mira Mar. There seemed to be no end to the amenities offered: fireplaces, wall safes, a service staff that included switchboard operators and uniformed doormen, mail chutes, long-distance telephone service, vacuum-cleaning systems, parquet floors, barbershops, and hair dressers. Lobbies had marble floors, rugs, and furniture— even stained glass windows.

At 125 Riverside Avenue, according to James Trager in *The New York Chronology*, the nine-story Turrets, the first apartment house on the avenue, had apartments with up to twenty rooms and six baths and boasted a white marble swimming pool, gymnasium, billiard room, basketball court, bowling alleys, banquet hall and a large ball room.

"As would be expected," Andrew S. Dolkart writes in his book, "buildings with higher rents tended to have finer and more costly decoration and more amenities . . . however, even the more modest amenities provided in middle class buildings were important factors in their success in the extremely competitive rental market."

In 1908, Riverside Avenue was extended to 158th Street and officially named Riverside Drive—probably in anticipation of the stream of automobiles already making their appearance and the "newfangled" electric bus waiting in the wings.

The drive and waterfront park made headlines in 1909 when ships from all over the world set anchor in the Hudson, from Forty-second Street north to Spuyten Duyvil, to celebrate the 300th anniversary of Henry Hudson's visit to the "New World." There were fireworks, ceremonies at the 110th Street reviewing stand, and the gift of 2,100 cherry

IN 1806, a village known as Manhattanville was established in the valley, which formed the sole break between today's Morningside Heights and Washington Heights. Straddling the famous Bloomingdale Road and Manhattan Street (present-day Broadway and 125th Street), the town became a conspicuous reference to city planners who were fervently limning a grid-patterned network of streets to the island's upper reaches. Manhattanville emerged as both resort and suburb, and as a prominent residential, manufacturing, and transportation hub. By the mid-1800s, this picturesque locale was the convergence of river, railroad, and stage lines. Eight miles above city hall, in a New York widely referred to as the Empire City, Manhattanville was the uppermost touchstone of that city's pulse.

A diverse population has historically characterized Manhattanville. American patriots and British loyalists intermarried. Residents included slave owners, Quaker antislavery activists, and black abolitionists. Tradesmen, poor laborers, and wealthy industrialists commonly worshipped under the same roof. The town was a toehold for newly arriving Americans and a homestead of some citizens with ancient lineages.

Manhattanville flourished naturally as a nexus of various transportation arteries. With the advent of rapid and mass transit in particular, transportation inevitably absorbed the town's ancient corridors, the ghosts of which today still haunt the modern thoroughfares of 125th Street, Broadway, and the noble currents of the Hudson River.

Eric K. Washington, *Manhattanville: Old Heart of West Harlem*

trees from Japanese residents of the city, to be planted along Riverside Drive. And to cap the event, Wilbur Wright flew his plane from Governors Island to Grant's Tomb and back again—the first airplane flight over Manhattan Island.

Over the decades since then, Riverside Drive has solidified its standing as one of the city's premier addresses—and the scenic spine for Manhattan's Upper West Side. Postal workers delivering mail to addresses on the drive and adjoining streets could literally be said to be name droppers. Many celebrities chose to live in the neighborhood at some point in their lives, and many still do. A partial list from the past would include Babe Ruth, George and Ira Gershwin, Theda Bara, Victor Herbert, Mary Pickford, Francis X. Bushman, future Supreme Court justice Harlan Fiske Stone, Marc Chagall, Humphrey Bogart, William Randolph Hearst,

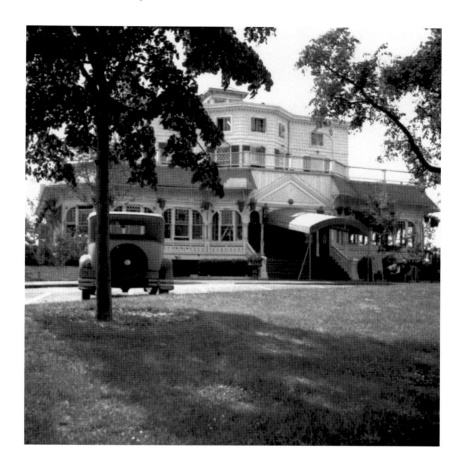

The Claremont Inn, just north of Grant's Tomb, was long considered America's most famous road house. It later became a restaurant and was destroyed by fire in 1951.

Marion Davies, Saul Bellow, and Dorothy Parker (whose family outings included walking her Boston terriers in Riverside Park). And the internationally known Claremont Inn, just north of Grant's Tomb, had its own guest roster of the famous, including Lillian Russell, Admiral George Dewey, and the Vanderbilts, Whitneys, and Morgans. When the inn later became a restaurant, it served the likes of Cole Porter and New York City mayor Jimmy Walker.

The era of mansions is long gone. The Schwab Mansion was bulldozed in the late 1940s after Mayor Fiorello LaGuardia rejected it in favor of Gracie Mansion as his official residence; it was replaced by Schwab House, a large

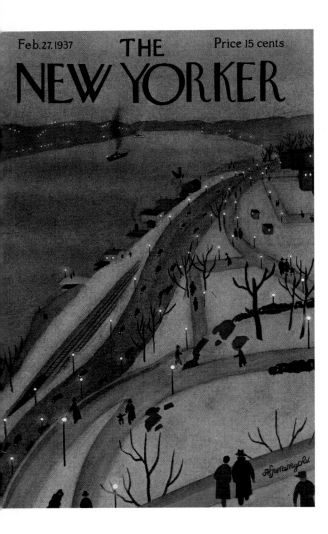

This fanciful, light-flecked view of the park, river, and highway was created by Arthur Kronengold as a 1937 cover for the *New Yorker* magazine.

apartment complex. Today, only two free-standing houses, both of them landmarks, remain: the former Schinasi Mansion at Riverside Drive and 107th Street and the Rice Mansion at Riverside Drive and Eighty-ninth Street.

The Rice Mansion, which is now Yeshiva Ketana of Manhattan, was the site of a bitter preservation battle in the 1980s. The building made headlines much earlier than that. In 1905, Julia Rice began her campaign against noisy river traffic, especially the sirens and whistles sounded by tugboat pilots. A year later, Mrs. Rice founded the Society for the Suppression of Unnecessary Noises. Among the society's targets: firecrackers, factory whistles, and boys who clacked sticks along iron fences.

Much More Than Residences

By the early 1900s, Riverside Drive and Riverside Park had become the setting for monuments and sculptures inspired by the City Beautiful movement, whose nationwide goal was to promote urban planning, including everything from transportation to works of art in public places.

"Designers sited many of these monuments," writes Elizabeth Cromley in a 1984 issue of the *Journal of the Society of Architectural Historians*, "so they would form visual links between residential streets . . . and the park itself. They mediate between the architecture of the street and the vegetation of the park." (Indeed, the son of Frederick Law Olmsted was considered the intellectual leader of city planning in the early twentieth century.)

Let's take a stroll northward for a look at some of the noteworthy monuments and memorials, both on the drive and in the park.

An eight-foot-tall bronze and stone sculpture of Eleanor Roosevelt, created by Penelope Jencks, is the first statue in

Feb. 27, 1937 THE Price 15 cents

NEW YORKER

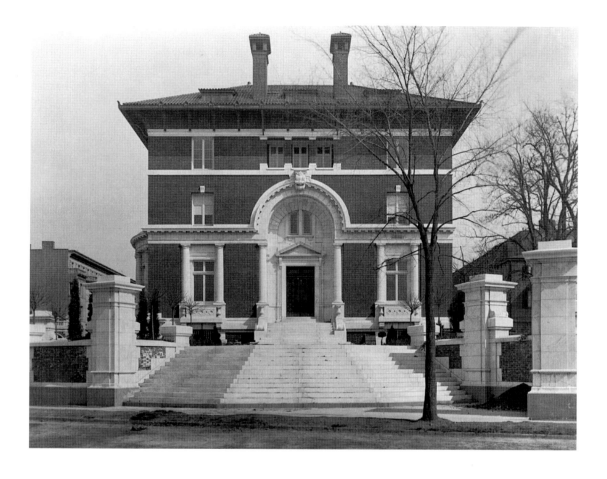

(above) The former Rice Mansion at Riverside Drive and Eighty-ninth Street is now Yeshiva Ketana. Built in 1901 by Isaac L. Rice, a lawyer, it was originally called "Villa Julia" for his wife and featured a reflecting pool and colonnaded garden.

A bas-relief at the side entrance of the former Rice Mansion on Riverside Drive at Eighty-ninth Street features a carving showing the family's six children.

CREATIVE artists have often felt themselves drawn
to Riverside Drive. George Bellows painted *Warships on
the Hudson* in 1909, depicting a day on which the fleet
assembled on the river, and *Summer Night, Riverside Drive*
with its girls in their summer dresses and strolling lovers.

Poets, too, have been inspired by the scene. In
"November Fifth, Riverside Drive," Katha Pollitt
describes how daylight "stuns the big bay windows
on West End Avenue" while, on the river, "a sailboat
quivers like a white leaf in the wind." In "Summer
Night, Riverside," Sara Teasdale rhapsodized about
a young couple sitting in the park "in the wild, soft
summer darkness" and watching the river "wearing
her lights like golden spangles glinting on black satin."
Not to be outdone is Harvey Shapiro. In "Riverside
Drive," translated from the Yiddish of Joseph Rolnick
by Shapiro, there is this:

At 310 Riverside Drive
A man on a low balcony,
Young but with mustache and beard—
His appearance not of here—
Stretches a hand toward
The west and shouts
Something like, See there!
And I stand like him
With my papers raised
Like an offering
To the light.
The two of us
Come for the first time
To this place,
To the red cliffs
Of this morning.

any New York City park to honor an American woman. It
is the centerpiece of the redesigned southern gateway to the
park at Seventy-second Street. A quotation from Eleanor
Roosevelt, engraved on the sidewalk in front of the sculpture,
reads in part: "Where, after all, do universal human rights
begin? In small places, close to home."

North of the Eighty-third Street playground in the park
is the Warsaw Ghetto Memorial, the first memorial in the
United States to commemorate the doomed but heroic
uprising by Jews against their Nazi captors in April and May
of 1943. A scroll describing the uprising and two bronze
boxes with soil from the concentration camps are buried
beneath the plaque.

Mt. Tom, just inside the park at Eighty-third Street,
was said to be a favorite viewing spot for Edgar Allan Poe

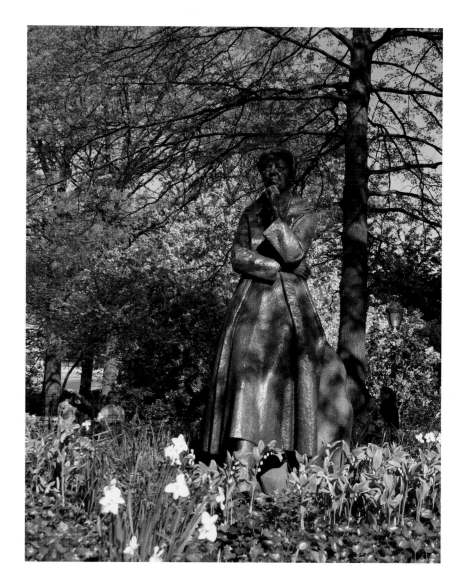

The bronze sculpture of Eleanor Roosevelt at the original Seventy-second Street base of the park presents the famous first lady as gentle and approachable. On the occasion of its dedication in 1996, Douglas Martin of the *New York Times* wrote that "she was born and died in New York City. . . . Today she comes home as a statue in Riverside Park."

during the summers he spent in New York. It was also one of the several sites originally considered for the Soldiers' and Sailors' Monument. The monument was finally constructed at Eighty-ninth Street on the fringe of the park. Dedicated on Memorial Day, 1902, to New Yorkers who died in the Civil War, it has names of the state's volunteer regiments carved

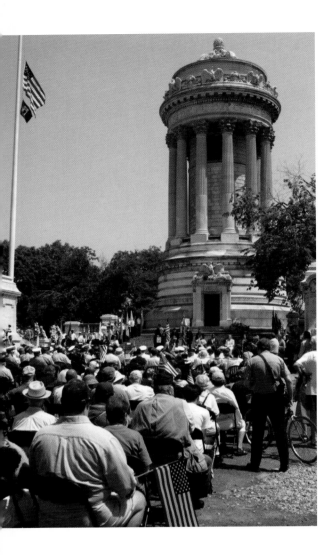

Veterans of the armed forces observe Memorial Day at the Soldiers' and Sailors' Monument. Built in the Greek temple style with Corinthian columns and pyramidal roof, the monument was designed by architects Charles and Arthur Stoughton and is a New York City landmark.

into its pillars, along with names of Union Army generals and the battles they led. Its cornerstone was laid by Governor Theodore Roosevelt in 1899. In 1976 it was named a New York City landmark.

The Joan of Arc memorial statue at Ninety-third Street is the work of sculptor Anna Hyatt Huntington and shows Joan standing in her stirrups, with sword aloft. The statue, one of the works of art credited to the City Beautiful movement, earned the Legion of Honor for its creator. Its pedestal contains fragments from Rheims Cathedral and stone from the tower at Rouen, where Joan was burned at the stake.

At One Hundredth Street, the Firemen's Memorial was dedicated in 1913 "To the Heroic Dead of the Fire Department." The marble slab contains flanking stone statues of a mother holding the body of her dead husband and consoling her child—representing Sacrifice and Duty. Its centerpiece is a bronze bas-relief panel showing a fireman urging his horse-drawn engine to the scene of a fire.

At 106th Street is an Equestrian Monument honoring Franz Sigel, a German-born general in the Union Army who led a corps in the Second Battle of Bull Run.

A statue at 112th Street pays tribute to Samuel J. Tilden, a reformer who led the attack on the Tweed Ring. Tilden ran for president in 1876, losing to Rutherford B. Hayes in a contested election.

The Lajos Kossuth statue at 113th Street honors the Hungarian patriot who became the symbol of representative government and national independence.

Modeled after the cathedral of Chartres, the massive and imposing Riverside Church at 120th Street was a gift to the city from John D. Rockefeller. The church has the world's largest carillon, with seventy-four bells, and it offers sweeping views from its 392-foot-high tower.

Directly east of Grant's Tomb is lovely, peaceful Sakura Park, an easterly extension of Riverside Park also known as

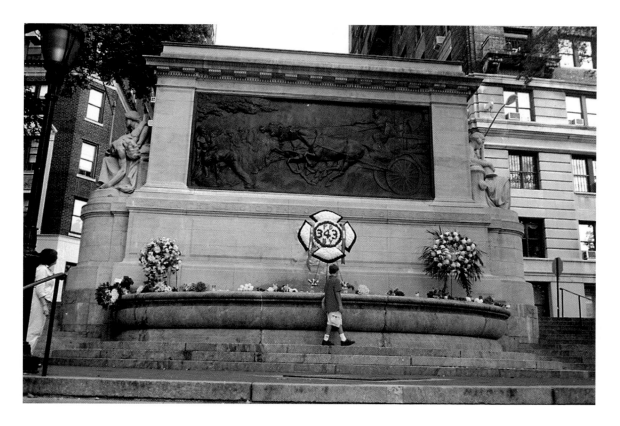

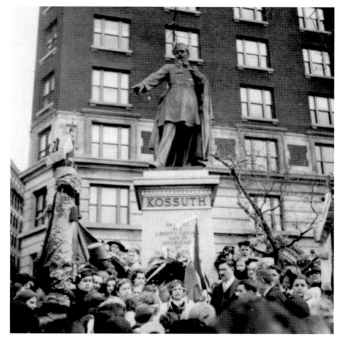

(above) In September 2002, the first anniversary of the 9/11 attack was the occasion for wreath laying and remembrances at the Firemen's Memorial at One Hundredth Street and Riverside Drive. Dedicated in 1913, the memorial was inspired by the heroic death of Deputy Fire Chief Charles Kruger in a Canal Street fire.

A statue at 113th Street honoring Lajos Kossuth, known as the father of Hungarian democracy, is the scene of a prayer for peace ceremony in 1935.

This drinking fountain at Riverside Drive and 116th Street was a gift to the city in 1910 from the Woman's Health Protective Association.

Claremont Park. "*Sakura*" is Japanese for cherry blossom, and its choice as the park's name commemorates the 2,000 cherry trees delivered to New York City parks from Japan in 1912. In 1960, a stone Japanese *tori*, or lantern, was donated to the park by the city of Tokyo.

Inside Grant's Tomb at 122nd Street rest the polished black sarcophagi of Ulysses S. Grant and his wife Julia. The massive neoclassical structure, designed by John Duncan, is located on a site once proposed by George Washington for the U.S. Capitol. More than a million people, including President William McKinley, attended its dedication on April 27, 1897, on the seventy-fifth anniversary of Grant's birth.

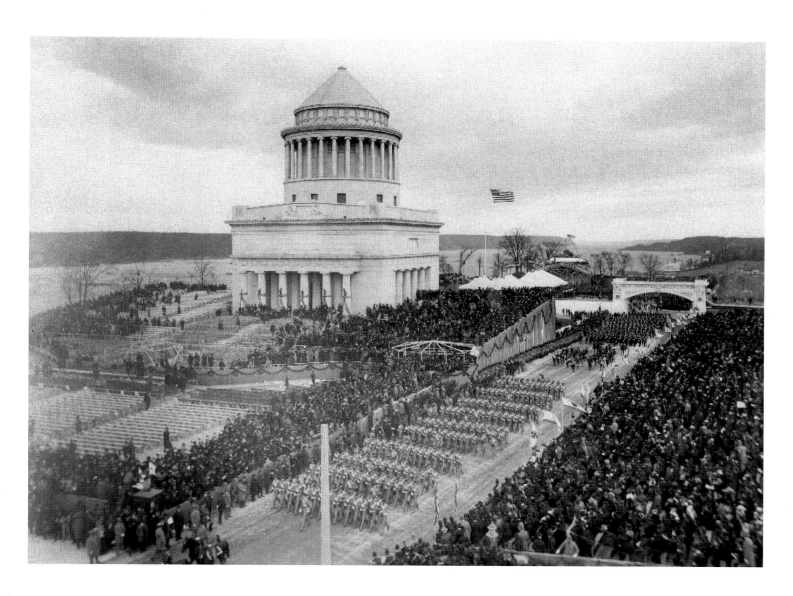

On April 27, 1897, a million people attended the dedication of Grant's Tomb—a crowd almost as large as the one that turned out for Grant's funeral parade in 1885. President William McKinley officiated. A century later, to the day, a smaller celebration was held as an observance of the extensive renovations that had been made to the monument.

One block north of Grant's Tomb, this small white marble monument is dedicated "to the memory of an amiable child." There is some dispute as to whether St. Claire Pollock was the son or nephew of George Pollock. But there is no doubt about the appeal of the simple five-foot-high memorial.

Just north of Grant's Tomb are a simple grave and headstone inscribed "to the memory of an amiable child," five-year-old St. Claire Pollock, who died on July 15, 1797, probably from a fall from the parkland cliffs. It is one of the few private graves on public land in the five boroughs of New York City.

The Ralph Ellison Memorial at 150th Street, a bronze monolith with the figure of a man striding through it, was created by sculptor Elizabeth Catlett. Ellison, author

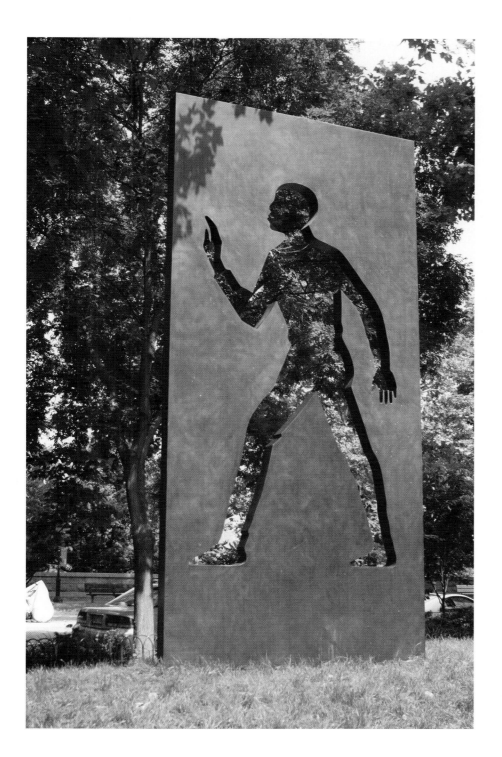

Though he published only one novel during
his lifetime, *Invisible Man* brought Ralph
Ellison undying recognition. His memorial at
150th Street includes biographical details and a
quotation from his searing portrait of alienation
and bigotry in America.

The Hudson River has been the stage for such major events as the 1909 return of America's Great White Fleet after its fourteen-month worldwide voyage. The Soldiers' and Sailors' Monument at the left serves as an illuminated beacon for the battleships.

of *Invisible Man* and other works illuminating the black American experience, lived opposite the park and is buried in Washington Heights.

Finally, at a 679 Riverside Drive address but deep within the park and overlooking the river, there is Riverbank State Park, a twenty-eight-acre recreational complex containing a fifty-meter pool, a skating rink, an eight-lane running track, and fields for football, soccer, and track and field events. Riverbank State Park, which runs from 137th Street to 145th Street, is independent of Riverside Park and is operated by New York State.

There is much more. For the location of these and other sights to be viewed "Along The Way," on the drive, and in the park, see the map inside the back cover.

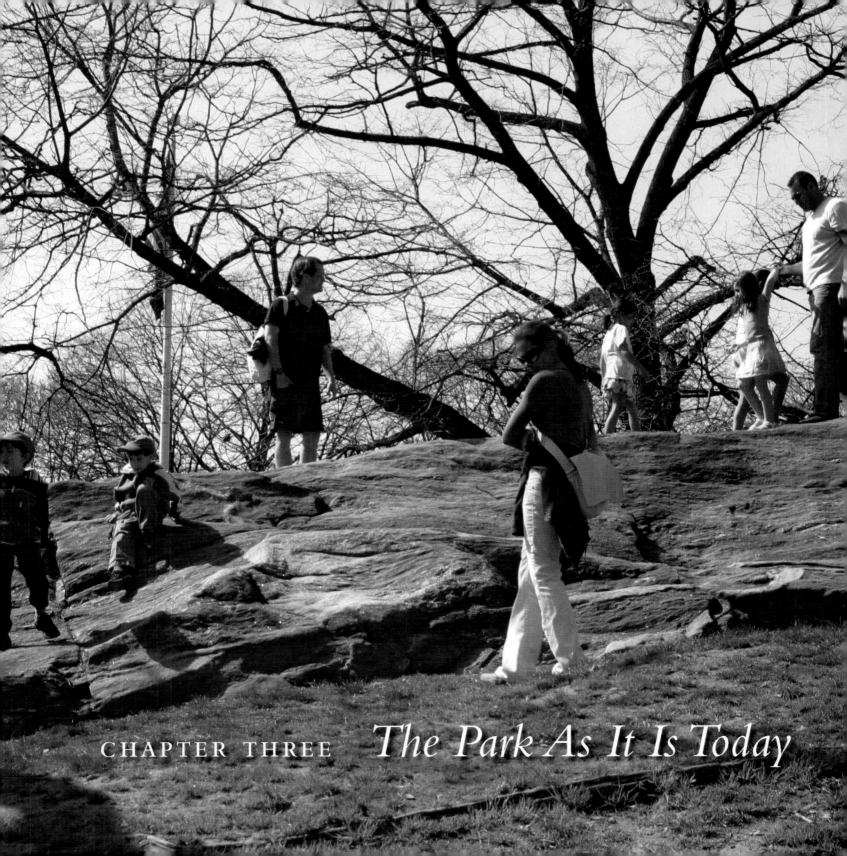

CHAPTER THREE *The Park As It Is Today*

They may look like snowflakes, but they're actually cherry-blossom petals that this young mother is strolling through with her baby and dog as the park welcomes springtime.

A VETERAN fisherman gazes contentedly down at the river and tells a passerby that "they're biting." He is hoping for striped bass, flounder, or fluke. "There should be a lot of big ones," he says.

A young mother remembers walking through the park down to her high school on West Sixty-first Street. She's grateful for the rubber mats in the playground and the equipment that's "safe because it's not too high."

A preschooler doesn't say anything at all. He just beams and spins around in wordless glee in the Dinosaur Playground.

———————

Clearly, Riverside Park is not only a park for all seasons of the year but for all seasons of life. The park now comprises 330 acres and runs from 62nd Street to 158th Street. Each year, millions of visitors come here. Many are, as would be expected, from Manhattan's Upper West Side, but if you listen to the conversations in other languages or see the cameras being trained on Grant's Tomb or the distant span of the George Washington Bridge, you will realize the many origins of its visitors.

Not too long ago, a well-known Minnesotan also tipped his hat to the park. On his *Prairie Home Companion* radio show, Garrison Keillor reflected on a visit there. "What a pleasure," he said. "Sitting, watching the world go by. Spring day, the sun is warm. It's noon . . . feeling happy . . . I like Riverside Park."

There's a lot to like—and not just on a springtime day. From sledding in winter to sunset concerts in summer, the calendar is crammed with events and activities. Yet, despite its heavy use, the park has never looked better. In the last few years alone, the list of improvements and work projects

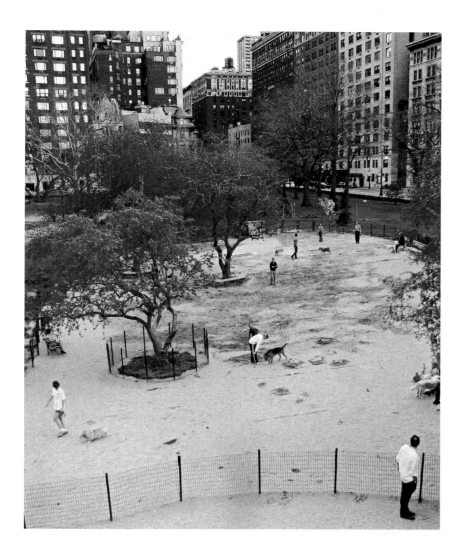

The dog run at Seventy-second Street, until recently Riverside Park's southern boundary, is one of four in the park. In all of them, dog owners take on the responsibilities of cleanliness, installation of plants and other landscaping, and raising funds for canine drinking fountains and new fencing.

includes memorials, playgrounds, tennis courts, ball fields, dog runs, paths, and walks, as well as new lighting, drainage, fencing, and the never-ending attention to the park's trees. Not to mention the dramatic expansion of the park south of Seventy-second Street, of which more later.

Overseeing these efforts is the work of the Riverside Park Fund, created in 1986 to preserve and enhance the quality of aesthetic and recreational life in the park. The Fund, which

BICENTENNIAL DAY! The Henry Hudson Parkway was closed to make a pedestrian promenade, and revelers crowded into Riverside Park and the empty highway for a grandstand view of the greatest parade of sailing vessels in modern times, or maybe ever: Operation Sail '76. . . .

Riverside Park became a vast, international picnic ground. Thousands stretched out on blankets, chatted with neighbors, read books and newspapers, played guitars, listened to transistor radios, and strolled over to gawk at the Russian four-masters when they anchored at the 79th Street Boat Basin. A few even visited Grant's Tomb. A spontaneous outpouring? Not exactly. Ogilvy & Mather, the ad firm, was doing a lot of image-polishing for the Democratic National Convention in New York that summer. But New Yorkers were rediscovering that they lived in a place where great things still happened. . . . On assignment for the *Times*, Richard F. Shepard had spent the Fourth near his youthful West Side haunts, and wound up his front-page Bicentennial piece quoting a California woman who was selling T-shirts on West 79th Street. "She said," he wrote, "what older New Yorkers would rarely confess: 'New York must be the most wonderful city in the world. I've never seen anything like it.' " The Upper West Side, like the rest of New York, had decided to start feeling good about itself again.

Peter Salwen, *Upper West Side Story*

currently has a constituency of approximately 9,000 families, is a partner with New York City's Department of Parks and Recreation. It raises money for maintenance and staffing, coordinates an extensive volunteer program, organizes restoration and renovation projects, offers educational programs, and sponsors cultural and recreational activities and events.

Fund president Jim Dowell makes it a point to walk the length of the park—all four and a half miles of it—at least twice a year. He likens Riverside Park to a series of neighborhood parks, connected not only by geography but by a common sense of stewardship and ownership.

Margaret Bracken, landscape architect for the park, agrees. "It's a complicated and challenging park," she says, "and that's part of why it is so appealing. People are invested in it on a very emotional level. They interact with it on almost a block-by-block basis."

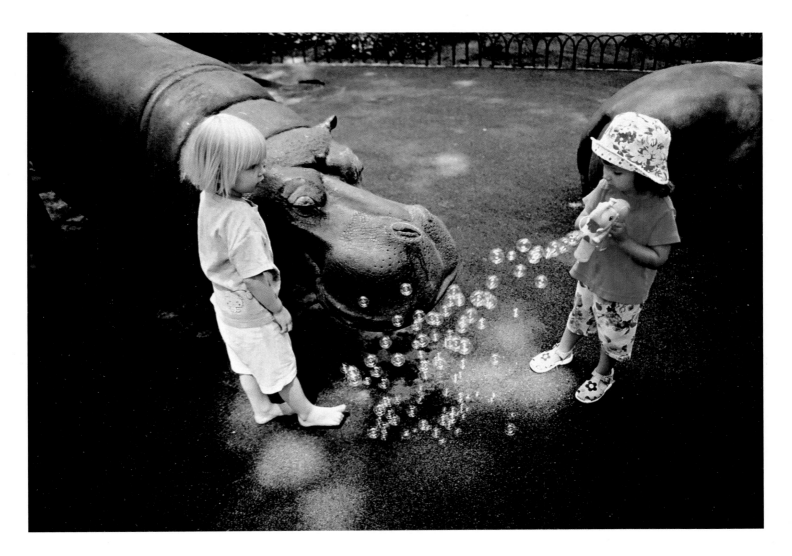

The Hippo Playground at 91st Street is one of several park playgrounds with a theme; others include the Dinosaur Playground at 97th Street, the Elephant Playground at 76th Street, and the Dolphin Playground at 126th Street.

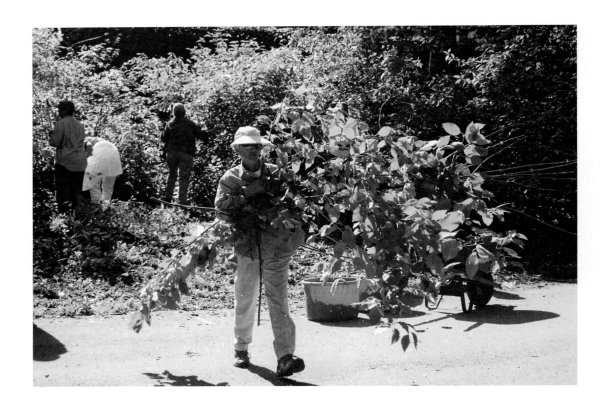

Members of the Sierra Club pitch in on a park-cleanup day. Outside groups often augment the work of the park's volunteers, who contribute tens of thousands of hours of their time each year. Their efforts peak on the semiannual It's My Park! Days in the spring and fall.

That interaction is evident in the annual town hall meeting that takes note of suggestions and, yes, criticisms relating to the park's operations. "People want to know not only what's going on," says K. C. Sahl, former park administrator, "but also what may not be on the radar screen."

Tens of Thousands of Hours of Dedication

At the heart of the Riverside Park success story are the volunteers who contributed almost 38,500 hours in 2006 on both group and individual projects to make the park, in Jim Dowell's words, "cleaner, greener, safer, and better." They do everything from weeding, pruning, raking leaves,

WHEN he takes tour groups through Riverside Park, Gordon Linzner is as much time traveler as guide. His two-hour tours begin at Sixty-eighth Street in the newest section of the park, Riverside Park South, then move north past Seventy-second Street and into the established park, ending at Ninety-fourth Street. Linzner covers a lot of parks—Central Park and Prospect Park in addition to Riverside—but his itineraries also include Grand Central Station and Greenwich Village. Although he also points out sights on the double-decker tourist buses, he's happiest when he's on foot with a smaller group that's focused on a particular locale.

Weather can be a factor, but as he puts it, "If enough people show up, I'll take them out there." He calls his tours "history-heavy," although, in the parks especially, he'll add "a little botany" to the mix. "I take them out on that pier in Riverside Park South for that fantastic view. I show them where the railroad tracks were exposed until the 1930s. We look at the marina—which a lot of people are surprised by—and the rotunda restaurant. We come up from the river at about Eighty-third Street for the Warsaw Memorial and Mt. Tom, then we head north along the promenade toward the gardens and the Hippo Playground and a view of the Soldiers' and Sailors' Monument."

A published author, Linzner finds little time these days for his writing, although he keeps vowing to get back to it. Maybe in that coldest part of the year when not "enough people" show up.

removing debris, and tending plantings to watering lawns, painting fences, and maintaining dog runs and recreational facilities. From time to time, their ranks include groups from the community, corporations, schools, and organizations like Americorps and New York Cares.

Debbie Sheintoch brings to her job as director of volunteers an impressive amount of experience and, just as important, a deep appreciation of Riverside Park. "It's like a living organism that keeps evolving," she says. "It's so full of history—and it has the grandeur of the river." Sheintoch was director of volunteer services for the Food Bank for New York City and has a certificate in ecological horticulture from the University of California.

You can see her in her pickup truck, tooling back and forth to the Seventy-ninth Street rotunda, where she has a tool room, or pedaling her bike to and from meetings with park people. When she's not on the move, you'll find her

Director of Volunteers Debbie Sheintoch, center, and volunteers in front of their headquarters at the Peter Jay Sharp house in the park at 107th Street. The century-old limestone building is used for storage and space for plant propagation as well as workshops and meetings.

at the Peter Jay Sharp Volunteer House just inside the park at 107th Street. The hundred-year-old limestone building became the volunteers' home base in September 2003.

A Tale of Two Gardens

They call themselves "The Garden People," and they have been at it since planting a row of daffodils in a vacant lot on Broadway. For twenty-six years now, they have planted and maintained the stretch of gardens on the promenade west of the Ninety-first Street entrance to the park. The first community garden in a New York City park, it has been chosen by *New York* magazine as one of the one hundred best things in the city and was featured in the film *You've Got Mail*.

It blooms from early spring until late autumn with a wide variety of both perennial and annual flowers and plants maintained by some forty volunteer gardeners. Everything grown is organic and recyclable. "We are gardeners first, and everything else second," says Marguerite Wolfe, who has been there from the beginning. "We love having our hands in the dirt."

More than two miles to the north, Jenny Benitez shares that same passion. Hers is a more challenging terrain, a once forlorn and neglected area that she has transformed into a cluster of gardens where she grows not only flowers—among them, roses, lilies, daffodils, pansies, and zinnias—but raspberries, peaches, plums, cherries, cabbage, Swiss chard, collard greens, basil, beets, eggplant, beans, corn, tomatoes, carrots, and fennel that she gives away to neighborhood people.

She is aided by volunteers, whom she regularly rewards with a barbecue dinner in the gardens, prepared by her and her husband, Victor. A retired assistant teacher, Benitez is a sunny, friendly person, and only one thing brings a frown to her face. "I hate weeds," she admits.

(Continued on page 54)

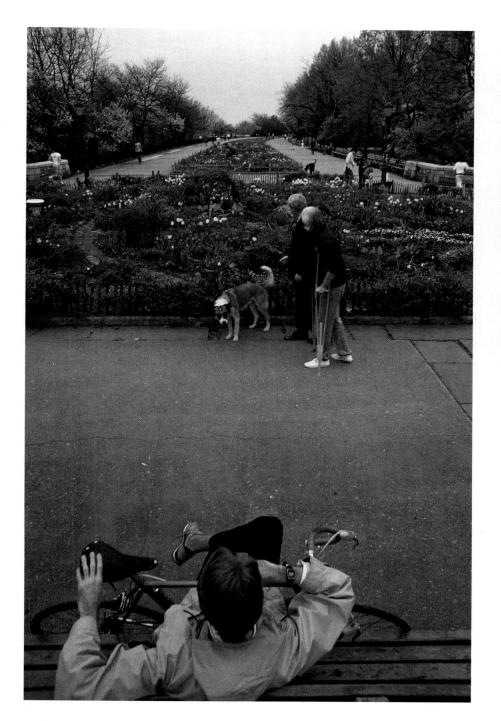

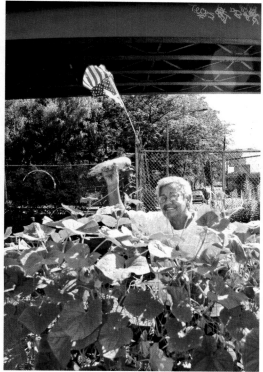

(above) At the 138th Street community gardens, Jenny Benitez is mistress of all she surveys—not only flowers but a wide variety of vegetables that she gives away to neighborhood people. A retired assistant teacher, she has created her gardens out of what had been a forlorn wasteland.

(left) The tranquil beauty of the flower gardens along the promenade at Ninety-first Street. The gardens, which are planted and maintained by the all-volunteer "Garden People," have their own water system and use no chemicals or spraying.

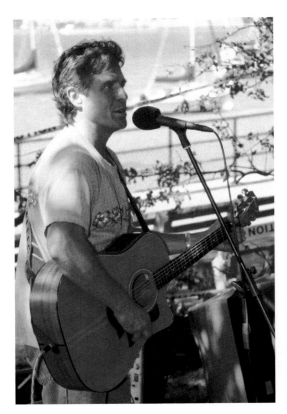

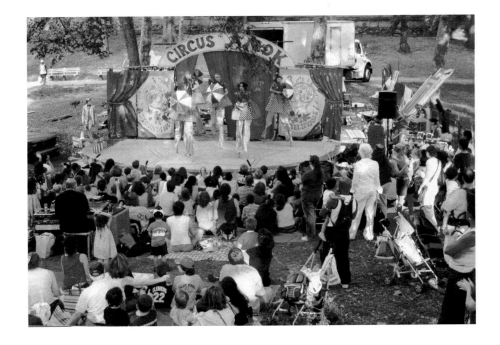

(above left) The arts in the park. Actors of Hudson Warehouse simulate a forest scene in a performance of Shakespeare's *Twelfth Night* at the Soldiers' and Sailors' Monument. The monument was also the setting for a musical tribute to jazz great Chico O'Farrill.

(above right) Guitarist and song writer David Ippolito entertains park goers down by the river.

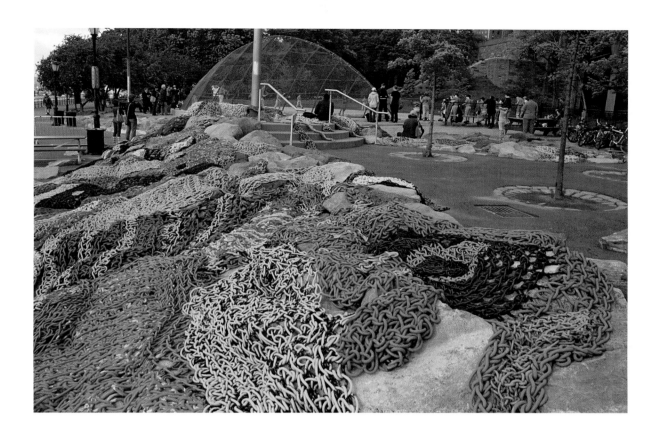

(above) *Puzzlejuice* by Orly Genger, with its mass of painted ropes, was one of the works of art featured in Studio in the Park, which celebrated the twentieth anniversary of the Riverside Park Fund in 2006. The eleven works included 8,000 orange balls floating in the river and a pink wire sculpture resembling railroad tracks.

(opposite page, bottom, and this page, left) Performances of Circus Amok are known for their canny blend of entertainment and social commentary. The group has been performing in the city's parks since 1989 and draws large, appreciative crowds in Riverside Park.

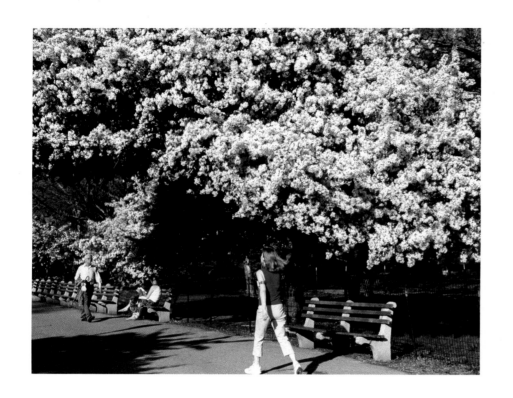

(left) It's spring, and the path leading south from the park's Ninety-fifth Street entrance is lined with blossoming cherry trees.

(below) As the snows of winter descend, the park becomes a quiet white haven—a silence punctuated by the boisterous sounds of sledding on its hills.

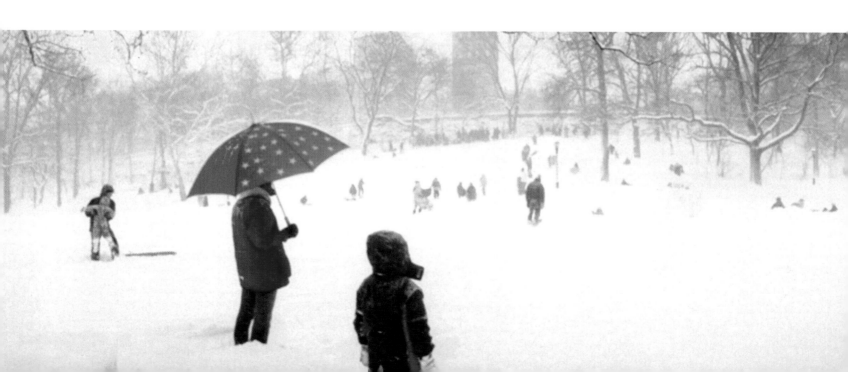

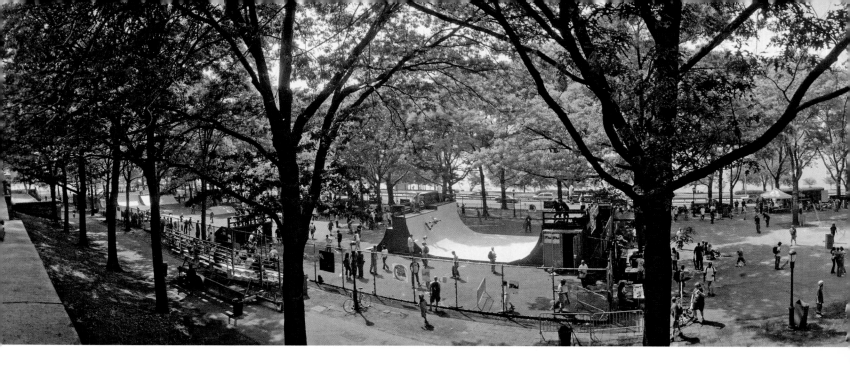

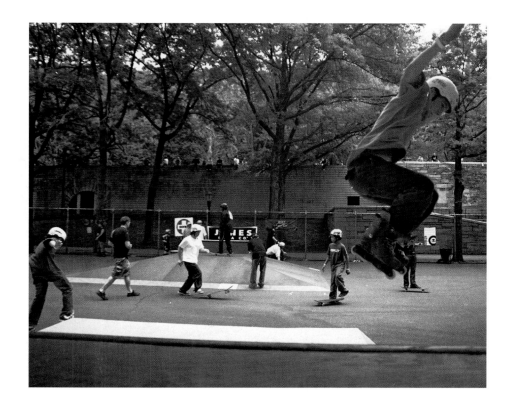

The ups and downs of skateboard competition day at the 108th Street skate park, the first of the public skate parks to open in the mid-1990s.

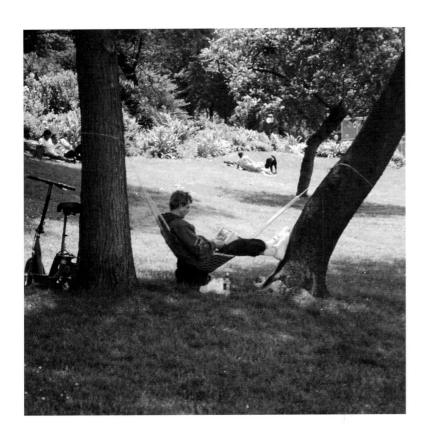

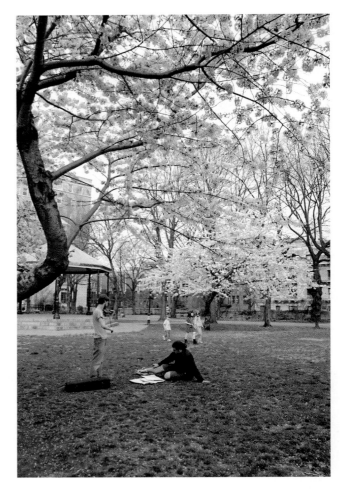

Passive moments have their place in the park: time to read in a hammock slung between trees; practice the violin in neighboring Sakura Park, across from Grant's Tomb; or simply doze on a rock next to the river.

(opposite page) The heat of competition is evident in the parry and thrust of a fencing competition at the Seventy-fourth Street running track and a pick-up basketball game at the Seventy-eighth Street courts. Swing-a-Rings at 105th Street tests both skill and strength.

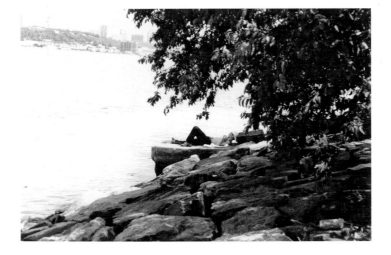

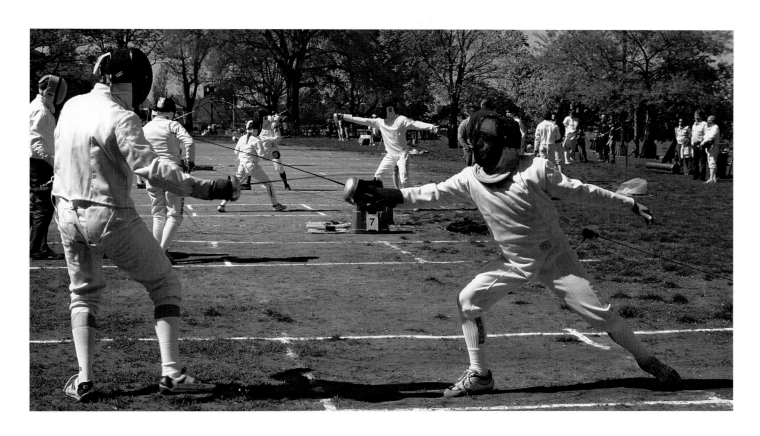

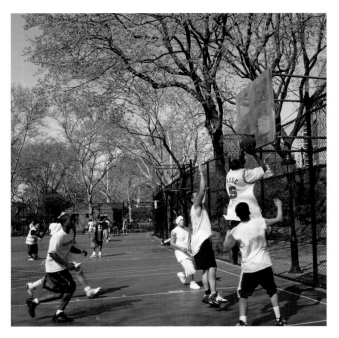

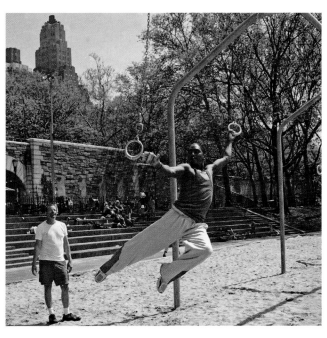

OUR BUILDING was filled with children, and we played out on the street. I learned to ride a bike on the street; I scraped my knees roller skating on the street. . . .Or we were in Riverside Park. From 79th Street, the park goes south to 72nd Street and north beyond Grant's Tomb at 122nd Street. But my world stopped at 84th Street. There's a roadway in the park that goes down a big hill and up a big hill where we went sleighing, or bike riding, seeing how far you could get up the hill before you had to start moving your legs again.

The 79th Street entrance to the Henry Hudson Parkway from Riverside Park was my Cinderella castle. There were two staircases with wide stairs that led down to the harbor. At the bottom was this big rotunda that the cars went around, and out of the center was a fountain with water coming out. Under the roadbed were the railroad tracks where the Pennsylvania Railroad traveled. You could look in these grated windows to where the trains ran underneath. And then you came out in the park and there was the Hudson River, which was clean and pristine. On the other side there was nothing but the Spry sign. During that funny eleven, twelve, thirteen-year-old time when I wanted to be alone, Riverside Park was my garden. I would lie on the grass by myself for hours.

Reminiscences of Jane Bevans, Manhattan-based attorney and artist, from *It Happened in Manhattan,* by Myrna Katz Frommer and Harvey Frommer.

(Continued from page 46)

A Green Ribbon That Ties It All Together

In a metropolis such as New York, a space like Riverside Park also brings a sense of separation from all the clamor around it and serves as a kind of horizontal antidote to the looming verticalness of the city. Jim Dowell refers to it as "a green ribbon" that ties together many pursuits and interests. Here is a look at some of them. Predictably, the people who make it all happen figure prominently in each.

For children, the park offers fifteen playgrounds, several of them with themes, such as hippos, dinosaurs, dolphins, and elephants. There are birthday parties and storytelling hours. There is also a school and family program, begun in the spring of 2000 and run for the Riverside Park Fund by Terry Cohen.

Each year, more than 1,500 children, from the city's public and private schools, from kindergarten through

fifth-grade, visit the park. Cohen firmly believes that children must observe natural processes and learn about environmental issues firsthand in order to understand them. "If they can see and touch and feel things, they'll have a much deeper understanding," she says, "and they'll cultivate the desire to protect them." To help make that happen, she collects Christmas tree bottoms and gives the cross-cuts to teachers so that, back in the classroom, they can be examined for annual rings.

Families enjoy the sandbox in the River Run playground at Eighty-third Street. It is one of several of the park's fifteen playgrounds built around themes, which also include hippos and dinosaurs.

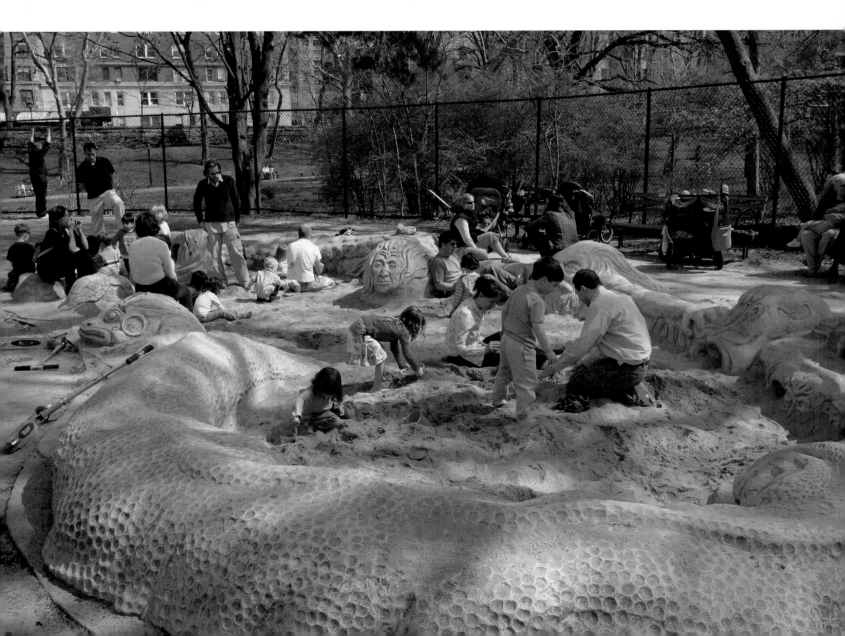

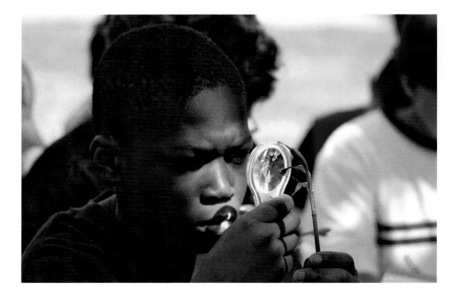

(above) Terry Cohen runs Riverside Park's environmental program. Her mission: to make the park an outdoor nature classroom for schoolchildren from kindergarten through the fifth grade. She also runs workshops for teachers.

(right) This youngster zeroes in on an example of nature's handiwork.

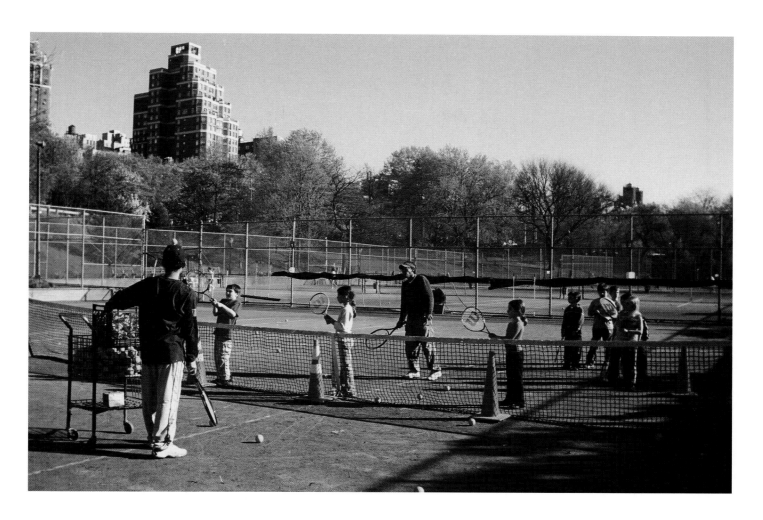

Cohen also runs after-school science programs, workshops for teachers, and family programs. "First you try to bring the classroom into the park, then you bring the park into the classroom," she says, then adds, without skipping a beat, "I am passionate about Riverside Park."

For the sports-minded, the park provides courts and fields for basketball, soccer, handball, volleyball, football, and baseball. There are also two grids of tennis courts that offer not only playing time but lessons and tournaments.

Children's lessons are part of the program at the Ninety-sixth Street Red Clay Tennis Courts near the river. There are also hard-surface courts at 119th Street. In addition to providing lessons and playing time, the park's well-maintained courts are the stage for annual tournaments.

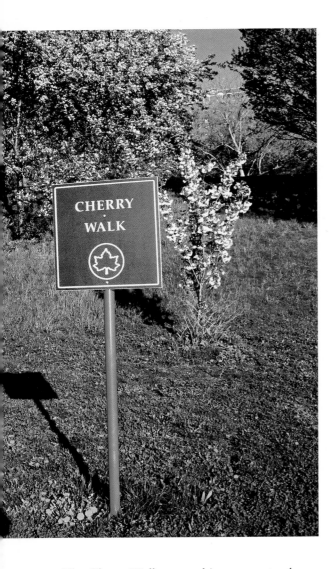

The Cherry Walk, opened in 2000, extends along the river from 100th Street to 125th Street and provides expansive views of the river and New Jersey Palisades. In addition, the north waterfront between 147th Street and 152nd Street is a popular starting point for a visit to the Little Red Lighthouse in Fort Washington Park.

The ten hard-surface courts at 119th Street share the locale with a wildflower meadow, while the ten red clay courts to the south, at Ninety-sixth Street, once a dust bowl, are now considered state-of-the-art quality for that type of surface—thanks to the efforts of the Riverside Clay Tennis Association.

Three blocks south of the skate park at 108th Street dangles one of the nation's first sets of Swing-a-Rings. Ten of them, seven feet above the ground and several feet apart, hang from a frame that spans a 175-foot stretch. On Swing-A-Ring Day in May, they fill the air with human pendulums. Now there is also a junior set of rings.

The Cherry Walk, which explodes with color in the springtime, extends along the river from 100th Street to 125th Street. This upper part of the park also features a new bikeway/pathway that runs east of Riverbank State Park from 135th Street to 145th Street. Visitors here can track the progress of the new Harlem Piers being built between 125th Street and 135th Street. One pier will be used as a dock for excursion boats and water taxis, the other for fishing and sunbathing.

The north waterfront runs from 147th Street to 152nd Street, where an open lawn extends to the shoreline and where one can stroll all the way up to the Little Red Lighthouse in the shadow of the George Washington Bridge.

The Birds and the Trees

Birdwatchers revel in their visits to the bird sanctuary in a densely forested area of the park that runs from 116th to 124th Street. More than one hundred species, including warblers, thrushes, and scarlet tanagers, are recorded each year.

According to Jeff Nulle, who has been conducting spring and autumn bird walks in the park for several years, migrating birds are drawn to areas that offer food and cover. "They have to cross over New York City," he says, "and they see

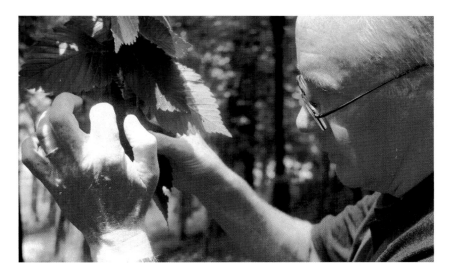

Ned Barnard considers the trees of Riverside Park "old friends" whom he enjoys seeing on a visit. Greeting them all would be quite a task: there are some 13,000 of them. Barnard is the author of a book on New York City's trees.

(below) Bird spotting group with guide Jeff Nulle, second from left, trains its sights on some of the park's approximately one hundred species. Nulle conducts walks in the spring and fall and estimates that, at the peak of migration season, tens of thousands of birds cross the park "on a good night."

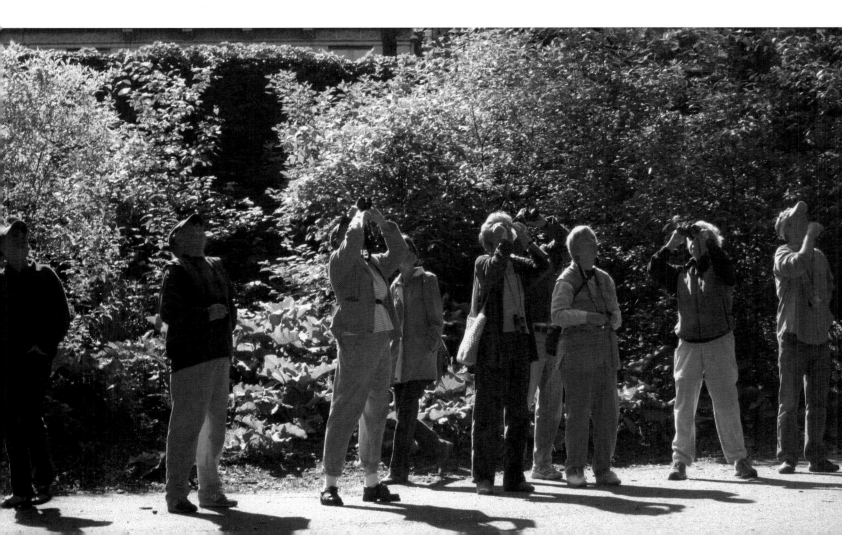

parklands like ours and Central Park. Birds use landmarks, too, and the Hudson River provides one of those landmarks."

Nulle works with park volunteers to plant bird-friendly species of plants, ground cover, and shrubs and to maintain the ingenious drinking fountain devised for birds south of the 119th Street tennis courts. "It's the only man-made drip except for the one in Forest Park, Queens," he says proudly. The "drip" entices birds to visit it from the higher branches of trees, adding to the bird count for his tour participants.

Those same trees are well known to Ned Barnard, author of *New York City Trees: A Field Guide for the Metropolitan Area*. On a recent walk through the park, Barnard pointed them out like old friends. "Look at that dawn redwood," he told a companion. "It was only four feet high a few years ago. This is a tulip tree, and there's a sweet gum and an American dogwood and over there, a black cherry. See that red oak with those ski trails on its bark? They're fast growers. And how about that tulip tree—that has to be at least 150 years old. You can tell by the striations and the way it's starting to bald."

He estimates that Riverside Park is home to some fifty different species and 13,000 individual trees. In an introduction to Barnard's book, New York City parks commissioner Adrian Benepe remembers exploring the park as a child. "I developed an affinity for these green treasures," he writes. "From the tall, solid oak to the gnarled crab apple with its fragrant clouds of pink blossoms, trees embody the strength and beauty of nature."

What's Happening on the Water

One of the stages for park activities is the mighty Hudson itself. There's a lot happening on the water as well as

I OFTEN feel drawn to the Hudson River, and I have spent a lot of time through the years poking around the part of it that flows past the city. I never get tired of looking at it; it hypnotizes me. . . . I guess I like it best on Sunday, when there are lulls that sometimes last as long as half an hour, during which, all the way from the Battery to the George Washington Bridge, nothing moves upon it . . . and it becomes as hushed and dark and secret and remote and unreal as a river in a dream.

Joseph Mitchell,
"The Rivermen" (1959)

the land—everything from kayaking to the New York City Aquathon in July.

The Seventy-ninth Street Marina is the only public-access facility of its type in Manhattan. There are more than one hundred boat slips here as well as launch moorings for canoes, kayaks, and sailboats. The marina is the docking

The West Seventy-ninth Street Boat Basin Café is a popular gathering spot for lunch, dinner, and special events. It is located just above the Seventy-ninth Street Marina, with slips for 105 boats. The park also has a seasonal café at 105th Street.

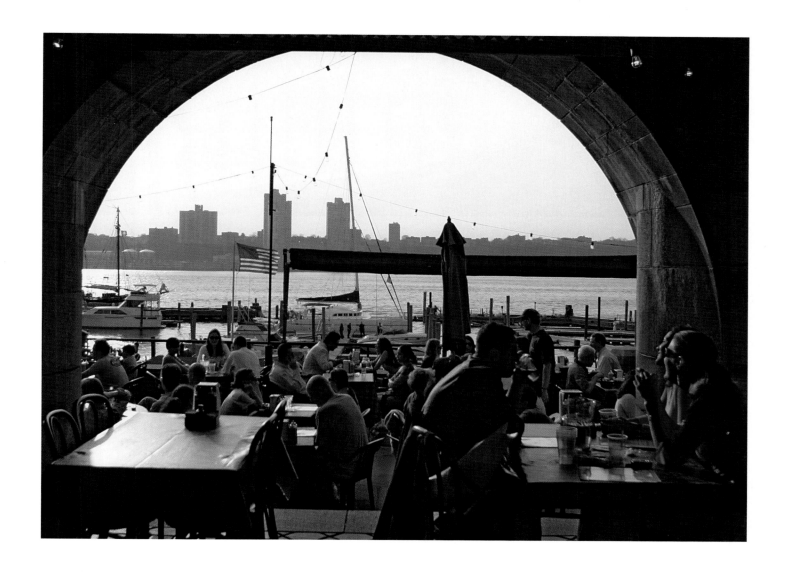

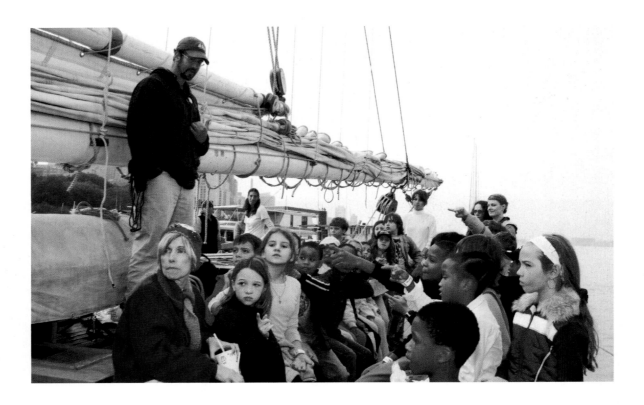

Schoolchildren are briefed by Captain Scott Cann before heading out into the Hudson on the *Clearwater* during its visit to the Seventy-ninth Street Marina. The *Clearwater* sails out of ports from Albany to New York City and offers a shipboard environmental-education program for children and teachers.

location for the Clearwater sloop, the 106-foot-long replica of an eighteenth-century trade ship, which acts as a floating environmental classroom as it cruises up and down the river.

———————

A woman with a parrot on her shoulder pauses at a dog run to check out that part of the animal world. Her parrot is less than interested, preferring to people-watch instead.

Graceful, gangly basketball players race back and forth on the court. Judging from the shouts of onlookers, the game must be close.

Alone on a gentle slope of grass, a practitioner of tai chi seems in his own world as he glides from stillness to movement.

The park as it is today.

CHAPTER FOUR *The Changing Park*

ALT WHITMAN would be pleased. The great poet loved the waters surrounding the city and celebrated them in his work. "Just as you feel when you look on the river and sky, so I felt," he wrote. Now, a thirty-two-mile route known as the Manhattan Waterfront Greenway represents a giant step in reclaiming public access to the city's 578 miles of waterfront for pedestrians, cyclists, and other users of nonmotorized transportation.

In November 2005, ground was broken for construction of the Harlem Piers between 125th Street and 135th Street, which will fill a gap between two esplanade sections of Riverside Park. Bicycle and pedestrian paths will also be created at the site.

As part of this grand design, Riverside Park is being extended south from Seventy-second Street to link up with Hudson River Park, which runs from Battery Park to West Fifty-ninth Street. The linkage is a source of great

[Whitman's] optimism still inspires us today. It animates the growing movement to reclaim the waterfront—from the south shore of Staten Island to the northern reaches of the Bronx River. . . . From Red Hook to Tribeca, Flushing to Harlem, St. George to Hunts Point and back down to the Battery, there are residents, activists, community groups, environmental organizations and leaders in government and elected office who see the potential of a waterfront renewed. . . .

The park proposals . . . vary in scope. Some are street ends, with small plantings and benches overlooking a canal. Others will transform long stretches of waterfront with public space, wildlife habitat, recreational amenities, private investment and port facilities. Many will be the links of the elusive emerald necklace of greenways along the water . . . bringing communities together.

New York is joining great cities around the nation and the world—like Chicago, San Francisco, Vancouver and Sydney—who have reclaimed their waterfronts with great success. In New York, community groups have shown especially strong leadership in creating visions for the future and moving them forward.

New York Waterfront Blueprint

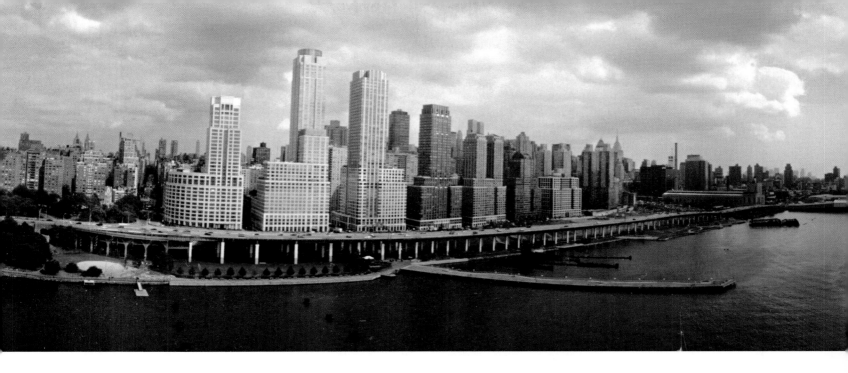

anticipation. "Riverside Park has long been the jewel in the waterfront crown," writes Phillip Lopate in *Waterfront*, "the best recreational facility on the edge of Manhattan island." Now that crown is taking on added luster.

"When all 29 acres of Riverside Park South are completed," says New York City Parks commissioner Adrian Benepe, "the pristine greenway will . . . create a seamless transition between Manhattan's two great parks along the Hudson."

Helicopter view of the Riverside Park South site, which runs from Seventy-second Street and, when completed, will connect with Hudson River Park at Fifty-ninth Street. Still undecided is the fate of the elevated Miller Highway shown here.

Birth of a Park

This transition is rapidly being realized. Since opening in April 2001, Riverside Park South, which has been designed by Thomas Balsley Associates and will cost $65 million, has created recreation fields, bike paths, pedestrian walks, picnic lawns, and viewing areas. A 750-foot-long pier with a

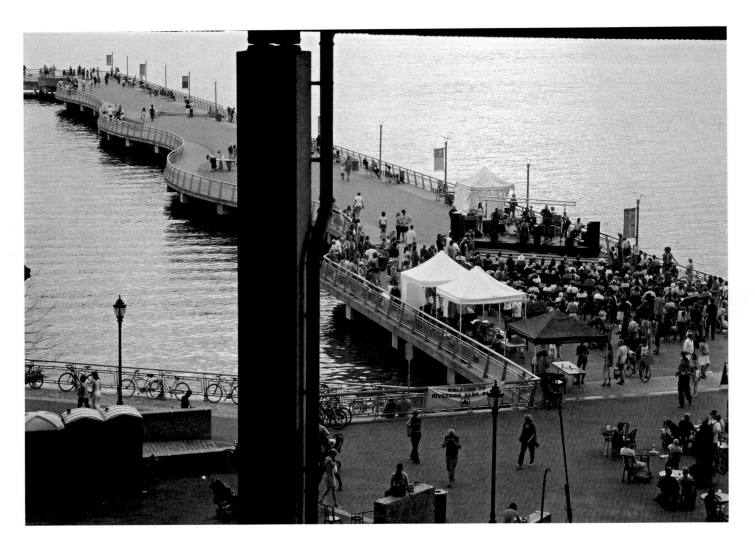

Centerpiece of the new park section is the 750-foot-long pier, built atop the remains of the original wooden shipping pier. Its shoreline-like southern side, along with marsh grasses and boardwalks, adds to the water-edge feeling of the area.

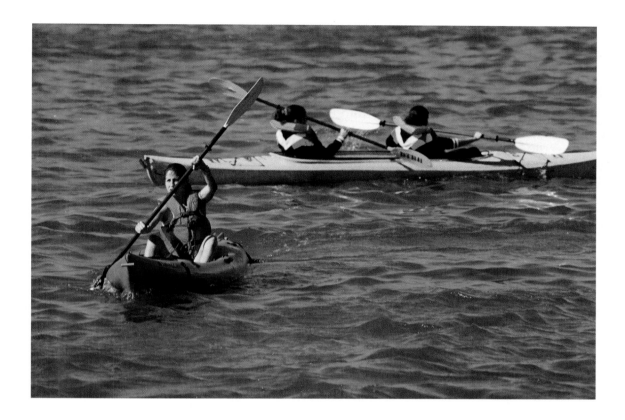

southern edge scalloped to resemble a shoreline has places for fishing and benches for sitting and enjoying panoramic views of the New Jersey shoreline, the George Washington Bridge, and the Manhattan skyline.

Events and activities abound—everything from free kayaking, pilates, and yoga classes to dance lessons and country fairs to an accordion festival and movies under the stars. For children there are a Soccer Tots program and Pee Wee Basketball. In July, Riverside Park is the scene of the New York City Aquathon, which includes a 1.5-kilometer swim and a 5-kilometer run.

None of this has happened overnight, or without controversy. Even after an agreement was reached in 1991 between a coalition of civic groups and Donald Trump,

Kayak lessons are part of the new park's offerings. The accent is also on learning in pilates, yoga, and dancing classes.

IN *Walking Manhattan's Rim: The Great Saunter*, Cy A. Adler contends that walking around "New York island's wet rim—or as close to it as we can get—is the best way to really appreciate and understand the grandeur and complexity of New York's waterfront." Adler describes twelve "legs" of that walk, which begins at the Staten Island Ferry Terminal and proceeds up Manhattan's western shore to the northernmost point at Inwood Hill Park, then turns south and east, along the Harlem and East Rivers, past the South Street Seaport and Wall Street, ending at the Staten Island Ferry Terminal.

Three of those "legs" take in the terrain of Riverside Park, including its extension south of Seventy-second Street—a development that clearly delights him: "Now that citizens of New York have reclaimed the use of the Penn Yards' (Riverside South's) delightful shore road," he writes, "bikers and walkers have a riverside path free of cars from the battery to the George Washington Bridge at 178th Street."

owner of the site at the time, work on the park did not begin until the spring of 1997. Under the terms of the agreement, Trump agreed to reduce by 40 percent the scope of his Riverside South development flanking the park to the east and also to fund the construction and maintenance of the park in perpetuity. (The land has been mapped as city parkland and is deeded over to the city as each section of the park is completed.)

Still to be decided is the fate of the elevated Miller Highway, which bisects the park and casts shadows over an eight-acre section. The long-term plan is to demolish the highway and relocate it under the new Riverside Boulevard and the park. Congress has allocated $15 million for preliminary construction work on that project. Construction has begun on the northbound tunnel shell, and work is planned to begin on the southbound shell in 2008.

A Bridge Thus Far

The fate of another structure is also being decided, and its story illustrates how past and future come together at Riverside Park South. The park has been built on the former site of the Penn Central rail yards, which were the receiving point for milk, grain, and vegetables arriving by rail from the north or by barge from rail heads in New Jersey.

In 1911, the West Sixty-ninth Street transfer bridge began being used, like other transfer bridges on the waterfront, to move freight cars to barges, which would then take them to ships or rail lines for destinations across the country.

The city's transfer bridges were initially used to bring freight in from New Jersey and to export it out of the city. After the Second World War, as port activity declined, the traffic was mostly into the city—primarily foodstuffs in the case of the West Sixty-ninth Street transfer bridge.

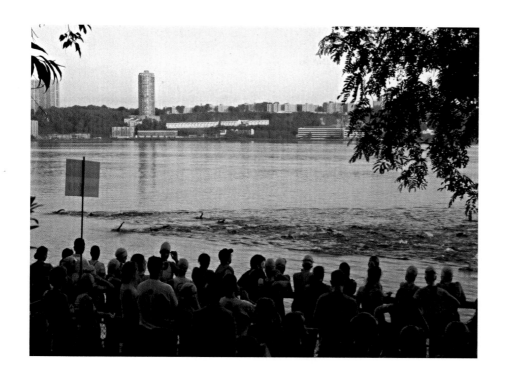

The waters of the Hudson provide a mighty continuum between the old and new parks. Competitive events in those waters include the New York City Triathlon, which begins with a 1.5-kilometer swim from Ninety-eighth Street to the Seventy-ninth Street Boat Basin, and the New York City Aquathon, featuring a similar swim from Seventy-second Street south to Fifty-sixth Street.

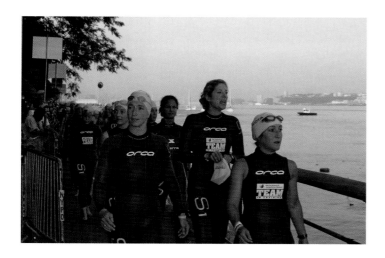

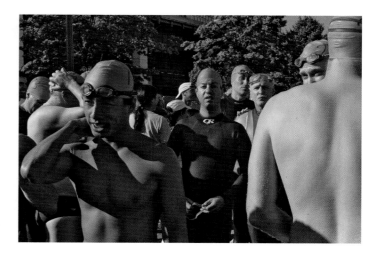

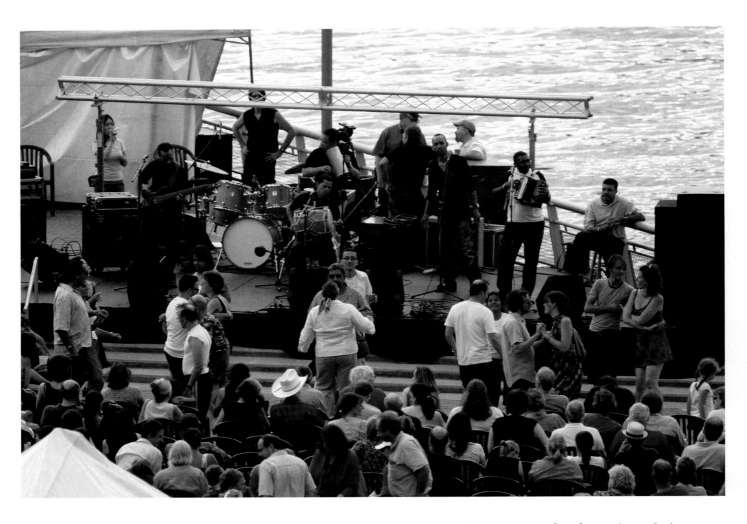

Dancers respond to the music at a Latin
accordion festival on the Seventieth Street pier,
which is also the heart of the action for the
annual West Side County Fair, Mamapalooza,
and movies under the stars.

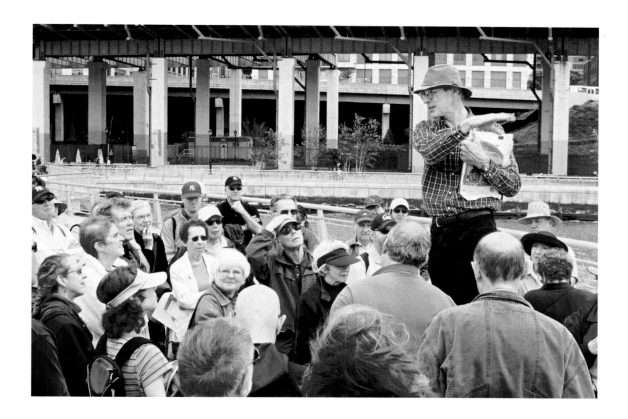

The design of the West Sixty-ninth Street bridge served as the model for most of the transfer bridges built later in New York Harbor. Rusting and ramshackle as it may look, the bridge is one of the city's most significant marine structures and has been listed in the National Register of Historical Places, thanks in part to the efforts of industrial archeologist Thomas Flagg.

Because of that history, it was decided to save the bridge from dismantling and removal and allow it to remain as an artifact. Then Michael Bradley had an even better idea. Bradley is the former executive director of the Riverside South Planning Corporation, a nonprofit civic organization formed to create the park's master plan and to coordinate its construction and maintenance, and he is now administrator

Industrial archeologist Thomas Flagg is an authority on the industrial history of the site, especially the role of the transfer bridges during what he calls "the heyday of railroad traffic" for New York.

> The railroad "transfer bridge" or "float bridge" is a structure used for loading freight cars onto or off a ship or barge, and was developed in the second half of the 19th century. It is one of the most efficient freight-handling devices known, allowing the loading or unloading of 800 tons of cargo in about 15 minutes, faster even than modern container cranes operate. It was once common at several ports of the world, but at none was the float bridge so extensively used as at the Port of New York, where 80 or 90 of them were in active use in the 1920s. Because of the geography of the port, with its many waterways and its high land costs, it would have been quite difficult for each railroad to serve the whole region without the invention of the transfer bridge, which made it possible to move freight cars over the harbor waters to any point on the waterfront A few transfer bridges remain in use but almost all of them are of a very simple type, not the more technologically advanced (and more interesting) type that was required to handle the large volumes of freight moved in the heyday of railroad traffic at New York.
>
> Thomas R. Flagg

for the Parks Department High Line project, which seeks to turn an abandoned railway site on Manhattan's lower West Side into an elevated park. Why not turn the bridge into a ferry landing, he suggested, complete with snack bar and ticket office, for boats to take people to and from the financial district, thereby relieving crowding on subways? The first phase of repair work has been funded by New York State and is scheduled to begin in 2008.

All Aboard

The site's heritage has also been saluted by the installation of a switching engine that was coaxed out of its retirement berth in Brooklyn, floated to a slip on Forty-fifth Street, then brought by flatbed truck to the park in August 2006. The ninety-five-ton, sixty-year-old engine had been used by the New York Central Railroad to pull freight cars to barges. "The idea was to animate that section of the park in a way that would be historically tied to its industrial past," says Parks Commissioner Benepe. "The locomotive will be a magnet for children, as only a locomotive can be."

Thomas Flagg was a consultant on the locomotive project. The rail yard was "the lifeline of the city," he says. "Even if the Hudson was frozen, or if there was a major strike, trains could bring in all the food and coal. And the switching engine, which sorted out cars and assembled whole trains at all hours and in all weather, was an unsung hero of the railroad."

Hugging the Waterfront

Responsibility for design of the waterfront park was given in 1991 to the landscape architectural firm of Thomas Balsley Associates. Their aim has been to create a park that

A sixty-year-old switching engine has found a new berth in the new park. The engine had been used to pull freight cars to barges. Its new assignment will be to serve not only as a symbol of the past but as a magnet for children who will visit its cab.

Magnificently rusty and weathered, the West
Sixty-ninth Street transfer bridge was the
model for other transfer bridges built in
New York Harbor and used for bringing freight
in from New Jersey. Plans are being considered
to convert it into a ferry landing for boat trips
to and from the Financial District.

is a natural extension of its parent park to the north, but also different—"proud and expressive of its industrial and transportation heritage, yet ecologically sensitive to its river edge environment."

The result has been a park design that hugs the waterfront and evokes, in subtle ways, the memories of the railroads that once thundered by. There are meandering wooden walkways, river overlooks, salt-marsh grasses, piers, and coves. The river and its waterside grasses are separated from the public lawns by quarry stone assemblages known as riprap, which serve as a protective layer to prevent erosion.

There is also room for the personal touch. At Sixty-eighth Street, you can find Linda's Lawn. It commemorates the life of Linda Stone Davidoff, "planner, advocate, public servant," who helped create the plan "that significantly reduced the size of the proposed private housing development and made possible this dramatic sweep of waterfront parkland." The lawn runs south for three blocks. Nearby, blocks of granite, shaped like boxcars and bearing the names of Penn Central and other railroads, bake in the sun, while ducks pad along the water's edge.

"Drawing on the tradition of Olmsted's Riverside Park to the north," says Thomas Balsley, the architectural firm's founder and principal designer, "we have tried to celebrate the history of the place and, in some subtle way, infuse it into the park experience."

That celebration and infusion are much in evidence as Riverside Park South adds to the ongoing story of "The Splendid Sliver."

Everywhere I walked on the waterfront, I saw the present as a layered accumulation of older narratives. I tried to read the city like a text. One textual layer was the past, going back to, well, the Ice Age; another layer was the present—whatever or whoever was popping up in my view at the moment; another layer contained the built environment, that is to say the architecture or piers or parks currently along the shore. . . . Writing about the Manhattan waterfront is like writing on water. . . . The very fact that the waterfront remains so elusive and mutable has ultimately ensured its fascination for me. . . . Its meanings have needed to be excavated, its poetry unpacked.

Phillip Lopate, *Waterfront*

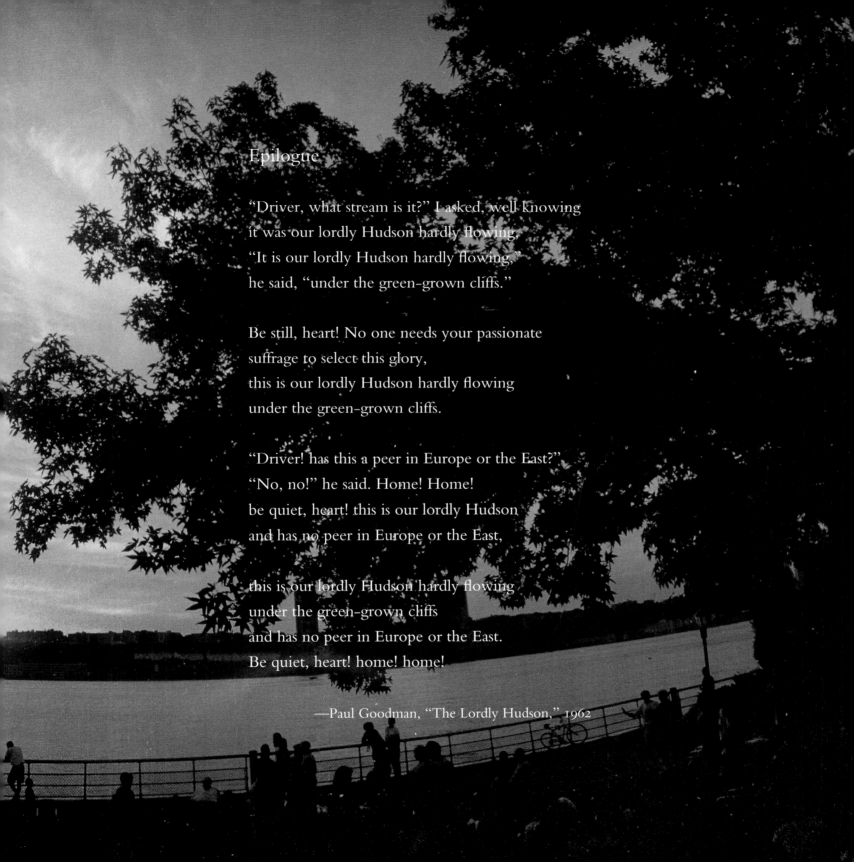

Epilogue

"Driver, what stream is it?" I asked, well knowing
it was our lordly Hudson hardly flowing,
"It is our lordly Hudson hardly flowing,"
he said, "under the green-grown cliffs."

Be still, heart! No one needs your passionate
suffrage to select this glory,
this is our lordly Hudson hardly flowing
under the green-grown cliffs.

"Driver! has this a peer in Europe or the East?"
"No, no!" he said. Home! Home!
be quiet, heart! this is our lordly Hudson
and has no peer in Europe or the East,

this is our lordly Hudson hardly flowing
under the green-grown cliffs
and has no peer in Europe or the East.
Be quiet, heart! home! home!

—Paul Goodman, "The Lordly Hudson," 1962

Acknowledgments

My thanks go to Jim Dowell and the people at the Riverside
Park Fund for their encouragement and support. Thanks also
to Charles McKinney for reviewing the historical material;
to Michael Bradley and Michael Koontz for their help on
Riverside Park South; to Ray Hooper for his early and
helpful design assistance; to Eric Washington, Ned Barnard
and Jeff Nulle for their interest; to our designer at Columbia
University Press, Milenda Lee; and to our editor, Michael
Haskell. Finally, and significantly, to my wife, Flavia, and
my children, Ellen and Christopher, for sharing their love of
Riverside Park with me for these many years.

—EDWARD GRIMM

The following people were invaluable to me in helping
Riverside Park: The Splendid Sliver become a book. DD,
my wife, encouraged and even prodded me to take certain
photographs of our beloved park. Christos Tountas has been
our computer expert and invaluable in so many other ways.
Ken Milford provided welcome advice on designers and how
to make our book look its best. The following people are also
appreciated: Dr. H. Bruce Schroeder, Joan S. Wilson, George
Kinoshita, Norman Rothchild, Joe Munroe, and, of course,
Emily A. and Ernest P. Schroeder, my parents. And, not least,
thank you, Omi Dworski, for the use of your ladder and other
good suggestions!

—E. PETER SCHROEDER

Photo and Image Credits

Title page: One of the summer highlights in Riverside Park is the series of sunset concerts that draw large crowds.
Image: E. Peter Schroeder.

Chapter 1. The Park as It Was

Opener: On a January day in the early 1900s, the hills leading down from Grant's Tomb prove inviting for sledding.
Image: Museum of the City of New York Print Archive.

The freight yards of the New York Central and Hudson River Railroad.
Image: Library of Congress/*Leslie's Illustrated Newspaper*, November 1877.

Carriages and bicycles vie for space on Riverside Avenue.
Image: Museum of the City of New York/*Harper's Weekly* c 1800s.

Frederick Law Olmsted.
Image: Museum of the City of New York Print Archive.

A Parks Department photo in its 1908 annual report of the
view south from 111th Street.
Image: New York City Parks Photo Archive/Annual
Reports.

The southern gateway to the park at Seventy-second Street.
Image: New York City Parks Photo Archive/Annual
Reports.

Riverside Avenue as a new century arrives.
Image: Museum of the City of New York Print Archive.

Squatters' shacks in the 1880s.
Image: Collection of the New-York Historical Society.

Spanning the Manhattan Valley from 129th to 135th Street at
12th Avenue, A viaduct completed in 1901 made possible
the northern extension of Riverside Avenue.
Image: Museum of the City of New York Print Archive.

A 1929 cartoon depicts an outcry against overdevelopment of
Riverside Park and Drive.
Image: Collection of the New-York Historical Society.

Newly named parks commissioner Robert Moses brought
about momentous changes in the 1930s.
Image: Museum of the City of New York Print Archive.

Children in 1939 enjoy one of the many playgrounds created
by Robert Moses in his Riverside Park revitalization project.
Image: New York City Parks Photo Archive.

A seaplane shares water space with docked pleasure craft at the
Seventy-ninth Street Boat Basin in 1947.
Image: New York City Parks Photo Archive.

A northward view of the railroad tracks and George Washington
Bridge in a 1932 photograph by Samuel Gottscho.
Image: Museum of the City of New York/The Gottscho-
Schleisner Collection.

Chapter 2. Along the Way

Opener: The S.S. *Washington Irving* docks at a Seventy-sixth
Street pier in November 1917.
Image: Museum of the City of New York Print Archive.

Rubble at 115th Street as the first stages of the park's massive
face-lift produced a temporary wasteland.
Image: The New York Public Library (Milstein Division
of United States History, Local History & Genealogy,
The New York Public Library, Astor, Lenox and Tilden
Foundations).

The wedding of Mary Clark and Washburn Hopkins, June 3,
1893, at the Cyrus Clark mansion at 175 Riverside Drive.
Image: Collection of the New-York Historical Society.

The park north of Grant's Tomb in 1916.
Image: New York City Parks Photo Archive, Annual
Reports.

An Afternoon Spin on Riverside Drive shows "the ever merry
bicyclers" on an outing.
Image: William Thomas Smedley, *Life and Character*.

The flag-bedecked Schwab Mansion was considered the most
lavish home ever built in Manhattan.
Image: Museum of the City of New York/Gift of Miss
Bartlett Lowdrey.

The view north from Ninety-sixth Street in 1930.
Image: The New York Public Library (Milstein Division
of United States History, Local History & Genealogy,
The New York Public Library, Astor, Lenox and Tilden
Foundations).

One of the first Riverside Drive buses as it heads south toward
Fifth Avenue and Fifty-seventh Street.
Image: Collection of the New-York Historical Society.

The Claremont Inn, just north of Grant's Tomb, was long
considered America's most famous road house.
Image: New York City Parks Photo Archive.

Fanciful, light-flecked view of the park, river, and highway by
Arthur Kronengold, a 1937 cover for the *New Yorker*.
Image: Original artwork by Arthur Kronengold/Copyright
© 1937 Condé Nast Publications.

The former Rice Mansion at Riverside Drive and Eighty-ninth
Street is now Yeshiva Ketana.
Image: Museum of the City of New York Print Archive.

A bas-relief at the side entrance of the former Rice Mansion on
Riverside Drive at Eighty-ninth Street.
Image: E. Peter Schroeder.

The bronze sculpture of Eleanor Roosevelt at the original
Seventy-second Street base of the park.
Image: E. Peter Schroeder.

Veterans observing Memorial Day at the Soldiers' and Sailors' Monument.
Image: E. Peter Schroeder.

Wreaths and remembrances at the Firemen's Memorial at One Hundredth Street and Riverside Drive in September 2002, the first anniversary of the 9/11 attack.
Image: E. Peter Schroeder.

A 1935 peace ceremony at the 113th Street statue honoring Lajos Kossuth, the father of Hungarian democracy.
Image: New York City Parks Photo Archive.

This drinking fountain at Riverside Drive and 116th Street was a gift to the city in 1910 from the Woman's Health Protective Association.
Image: New York City Parks Photo Archive, Annual Reports.

A million people attended the dedication of Grant's Tomb on April 27, 1897.
Image: James Bindon/Museum of the City of New York Print Archive.

A small white marble monument, one block north of Grant's Tomb, dedicated "to the memory of an amiable child."
Image: Collection of the New-York Historical Society.

Ralph Ellison's memorial at 150th Street includes biographical details and a quotation from *Invisible Man*, his searing portrait of alienation and bigotry in America.
Image: E. Peter Schroeder.

The 1909 return of America's Great White Fleet in the Hudson River.
Image: Collection of the New-York Historical Society.

Chapter 3. The Park as It Is Today

Opener: Rock climbing is the main attraction at Eighty-third
Street outside the River Run playground.
Image: E. Peter Schroeder.

A young mother strolls through cherry-blossom petals with
her baby and dog.
Image: E. Peter Schroeder.

The dog run at Seventy-second Street.
Image: E. Peter Schroeder.

The Hippo Playground at Ninety-first Street.
Image: E. Peter Schroeder.

Members of the Sierra Club pitch in on a park-cleanup day.
Image: E. Peter Schroeder.

Director of Volunteers Debbie Sheintoch and volunteers in
front of their headquarters at the Peter Jay Sharp house
107th Street.
Image: E. Peter Schroeder.

The flower gardens along the promenade at Ninety-first Street.
Image: E. Peter Schroeder.

Jenny Benitez at the 138th Street community gardens.
Image: E. Peter Schroeder.

Actors from Hudson Warehouse simulate a forest scene in a
performance of Shakespeare's *Twelfth Night* at the Soldiers'
and Sailors' Monument.
Image: E. Peter Schroeder.

Guitarist and song writer David Ippolito.
 Image: E. Peter Schroeder.

Performances of Circus Amok, which has been performing
 in the city's parks since 1989 and draws large, appreciative
 crowds in Riverside Park.
 Image: E. Peter Schroeder.

Puzzlejuice by Orly Genger, in Studio in the Park, which
 celebrated the twentieth anniversary of the Riverside
 Park Fund in 2006.
 Image: E. Peter Schroeder.

Blossoming cherry trees line the path leading south
 from the park's Ninety-fifth Street entrance in
 spring.
 Image: Edward Grimm.

The park becomes a quiet white haven under winter
 snows—a silence punctuated by the boisterous
 sounds of sledding on its hills.
 Image: E. Peter Schroeder.

A panoramic view south from 125th Street.
 Image: E. Peter Schroeder.

Skateboard competition day at the 108th Street skate
 park.
 Image: E. Peter Schroeder.

Passive moments in the park: reading in a hammock
 slung between trees; practicing the violin in neighboring
 Sakura Park; and dozing on a rock.
 Images: E. Peter Schroeder and DD Schroeder.

A fencing competition at the Seventy-fourth Street running track and a pick-up basketball game at the Seventy-eighth Street courts.
Image: E. Peter Schroeder.

Families enjoy the sandbox in the River Run playground at Eighty-third Street.
Image: E. Peter Schroeder.

Terry Cohen, who runs Riverside Park's environmental program.
Image: E. Peter Schroeder.

A youngster zeroes in on an example of nature's handiwork.
Image: E. Peter Schroeder.

Children's lessons at the Ninety-sixth Street Red Clay Tennis Courts near the river.
Image: E. Peter Schroeder.

The Cherry Walk, opened in 2000, extends along the river from 100th Street to 125th Street and provides expansive views of the river and New Jersey Palisades.
Image: E. Peter Schroeder.

Ned Barnard considers the trees of Riverside Park "old friends" whom he enjoys seeing on a visit.
Image: E. Peter Schroeder.

Bird spotting group with guide Jeff Nulle.
Image: E. Peter Schroeder.

The West Seventy-ninth Street Boat Basin Café.
Image: E. Peter Schroeder.

Schoolchildren are briefed by Captain Scott Cann before
heading out into the Hudson on the *Clearwater* during its
visit to the Seventy-ninth Street Marina.
Image: E. Peter Schroeder.

Chapter 4. The Changing Park

Opener: One of the wooden walkways close to the water in
Riverside Park South.
Image: E. Peter Schroeder.

Helicopter view of Riverside Park South.
Image: E. Peter Schroeder.

The 750-foot-long pier, built atop the remains of the original
wooden shipping pier, in Riverside Park South.
Image: E. Peter Schroeder.

Kayak lessons.
Image: E. Peter Schroeder.

The New York City Triathlon and New York City Aquathon
in the waters of the Hudson.
Image: E. Peter Schroeder.

Dancers at a Latin accordion festival on the Seventieth Street pier.
Image: E. Peter Schroeder.

Industrial archeologist Thomas Flagg.
Image: E. Peter Schroeder.

A sixty-year-old switching engine has found a new berth in
the new park.
Image: E. Peter Schroeder.

The West Sixty-ninth Street transfer bridge was the model for other transfer bridges built in New York Harbor and used for bringing freight in from New Jersey.
Image: E. Peter Schroeder.

Epilogue: Sunset on the Riveside park water front.
Image: E. Peter Schroeder.